Copyright © 2017 Dea Bernadette D. Suselo
All rights reserved.

ISBN-13: 978-1544764511
ISBN-10: 1544764510

www.facebook.com/DeaBernadette

Thailand

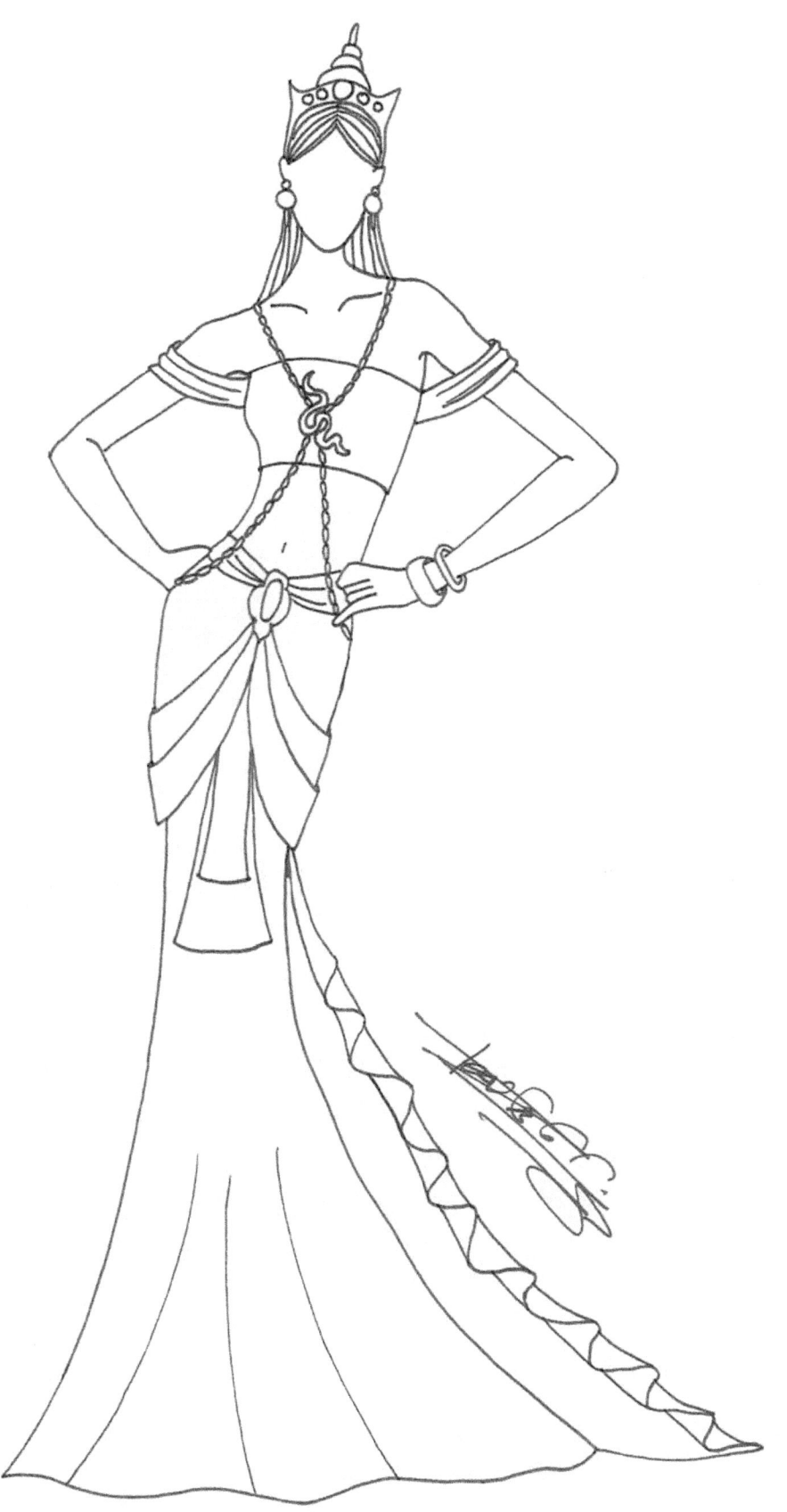

Thailand

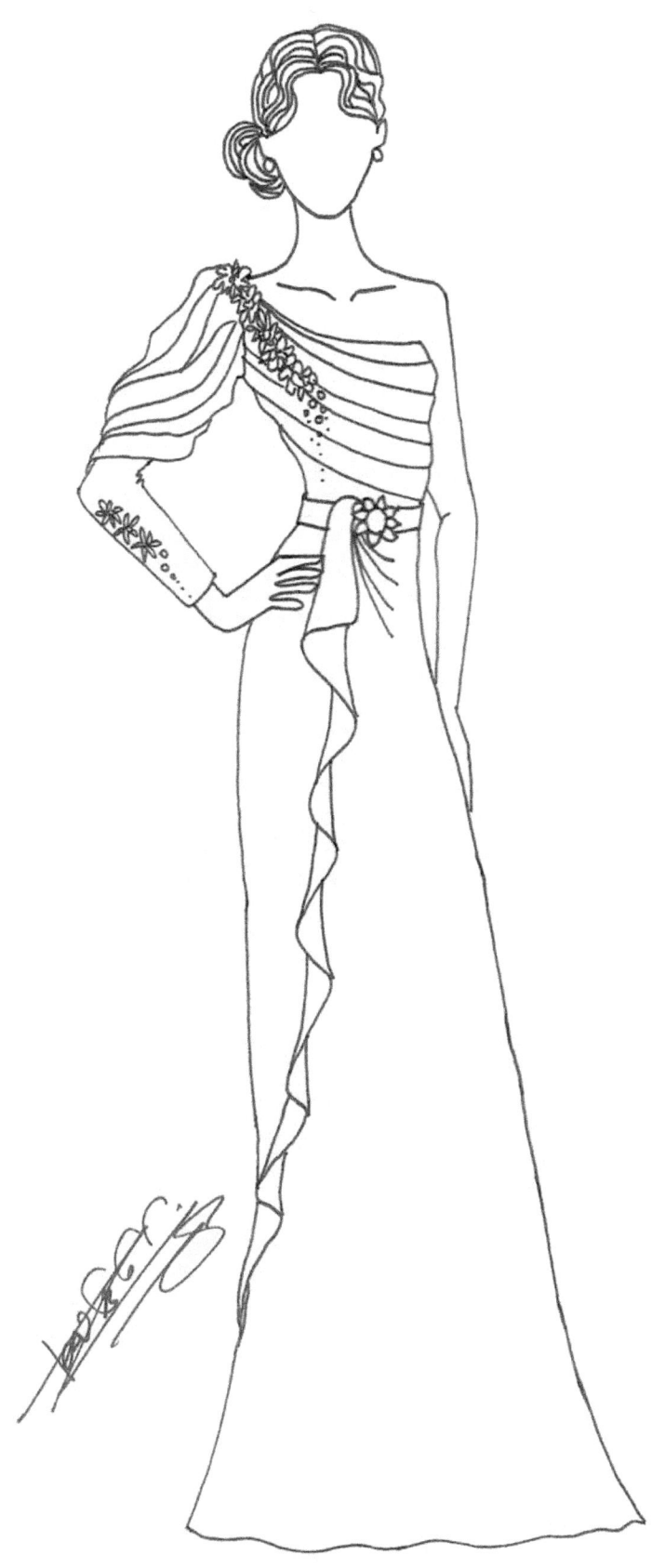

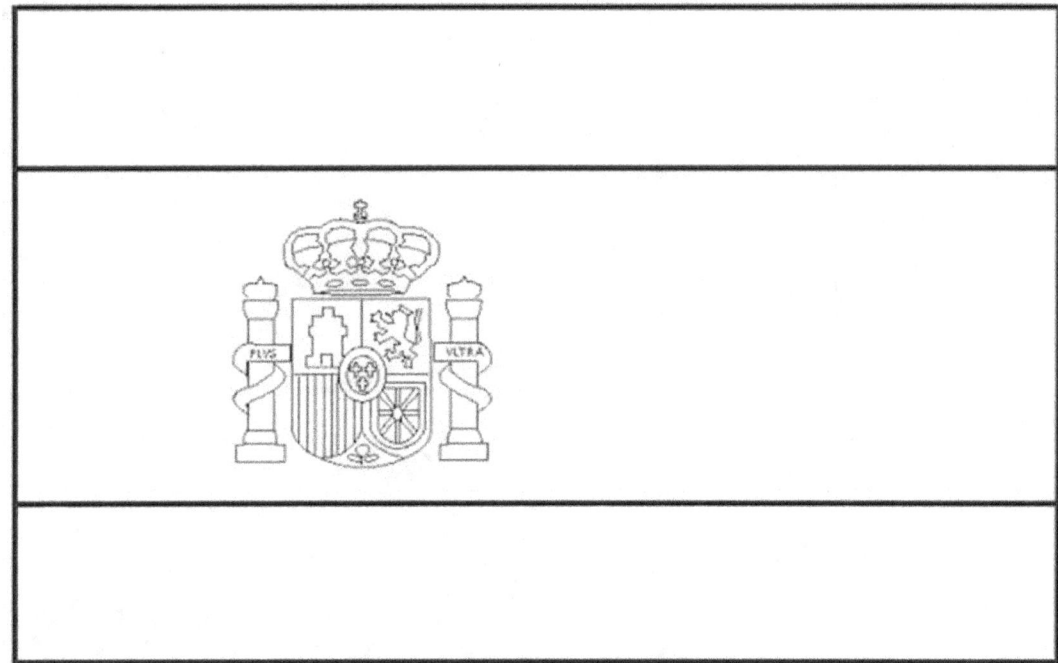

Spain

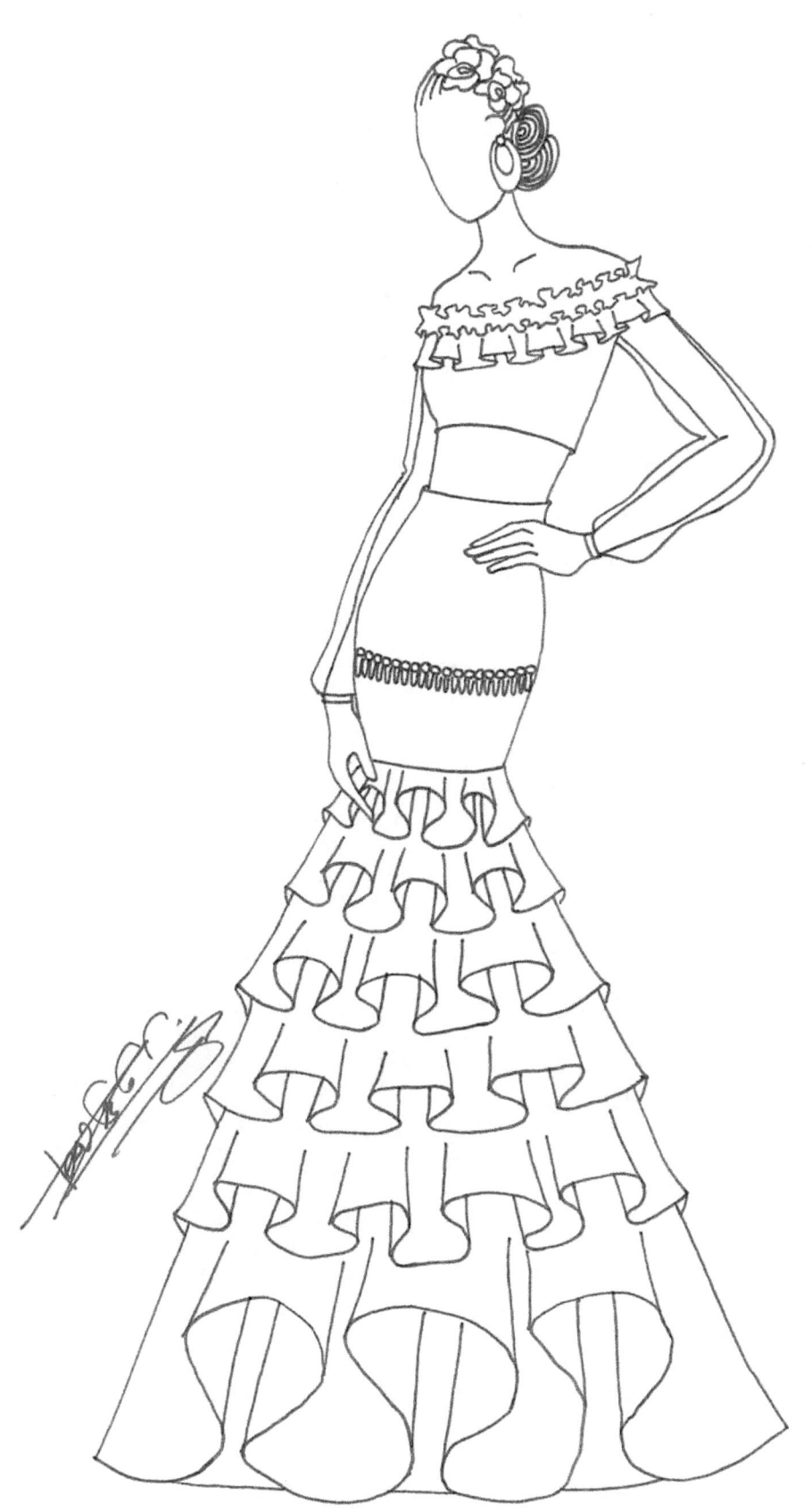

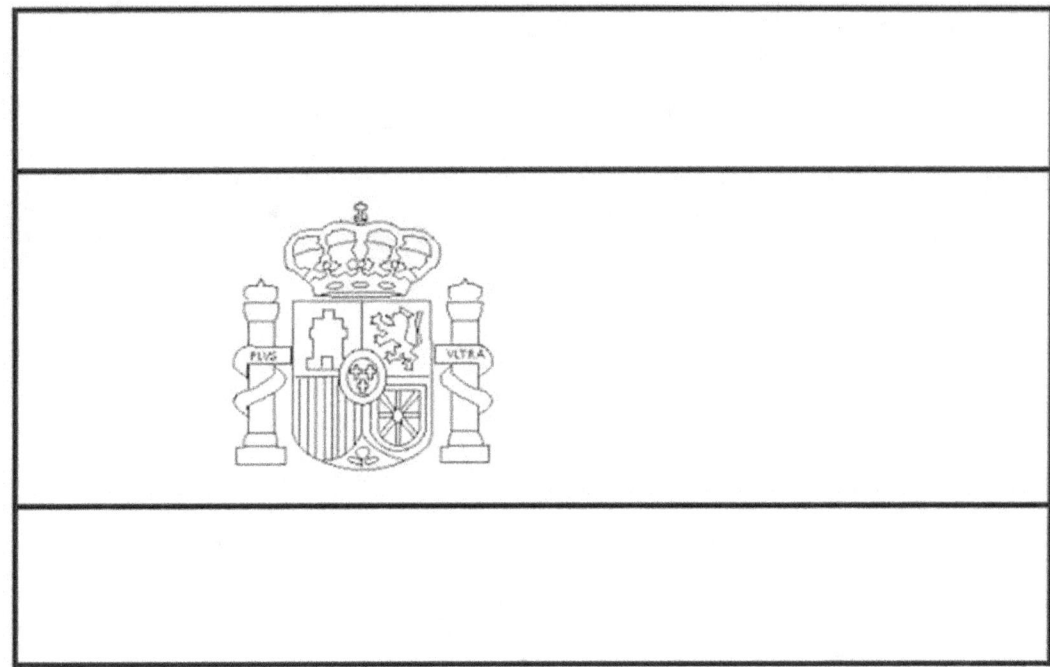

Spain

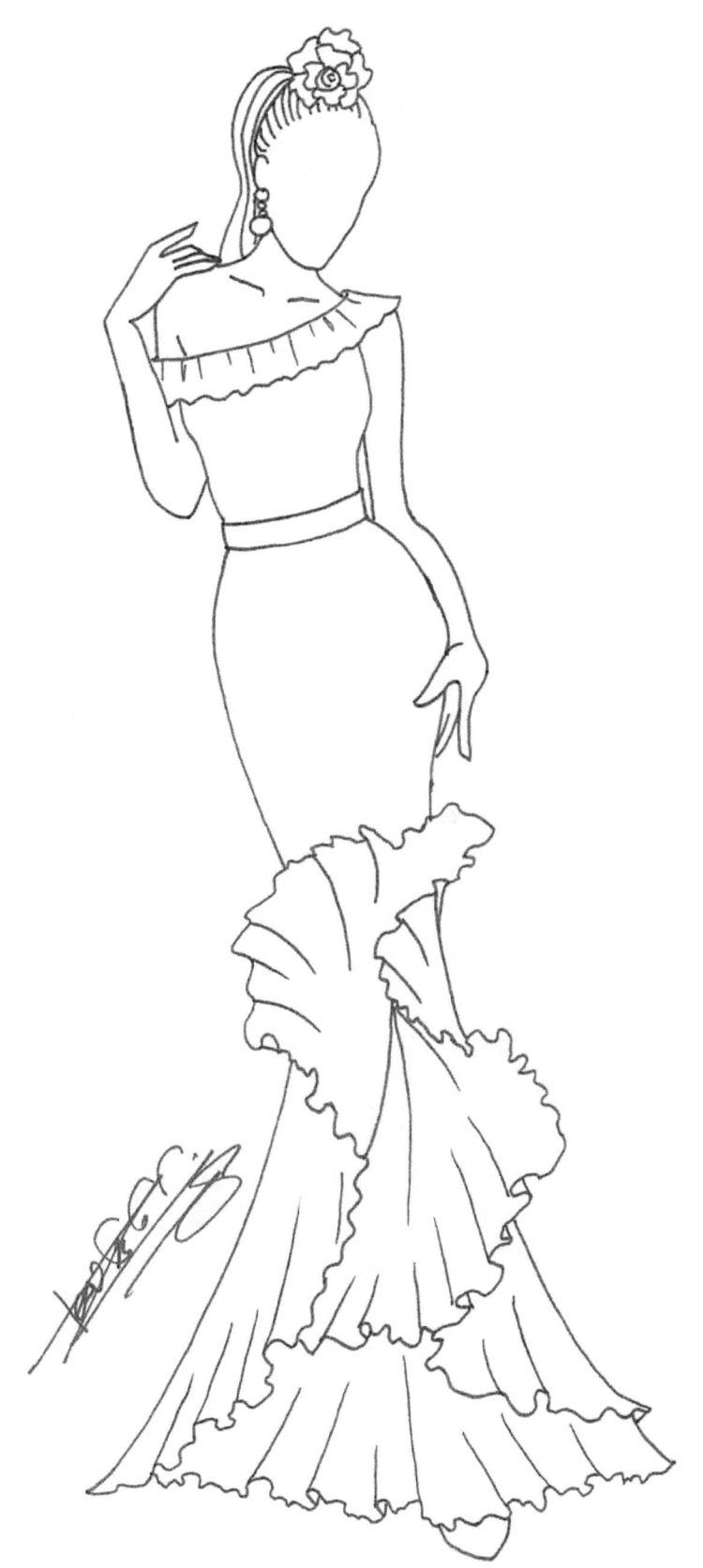

Russia

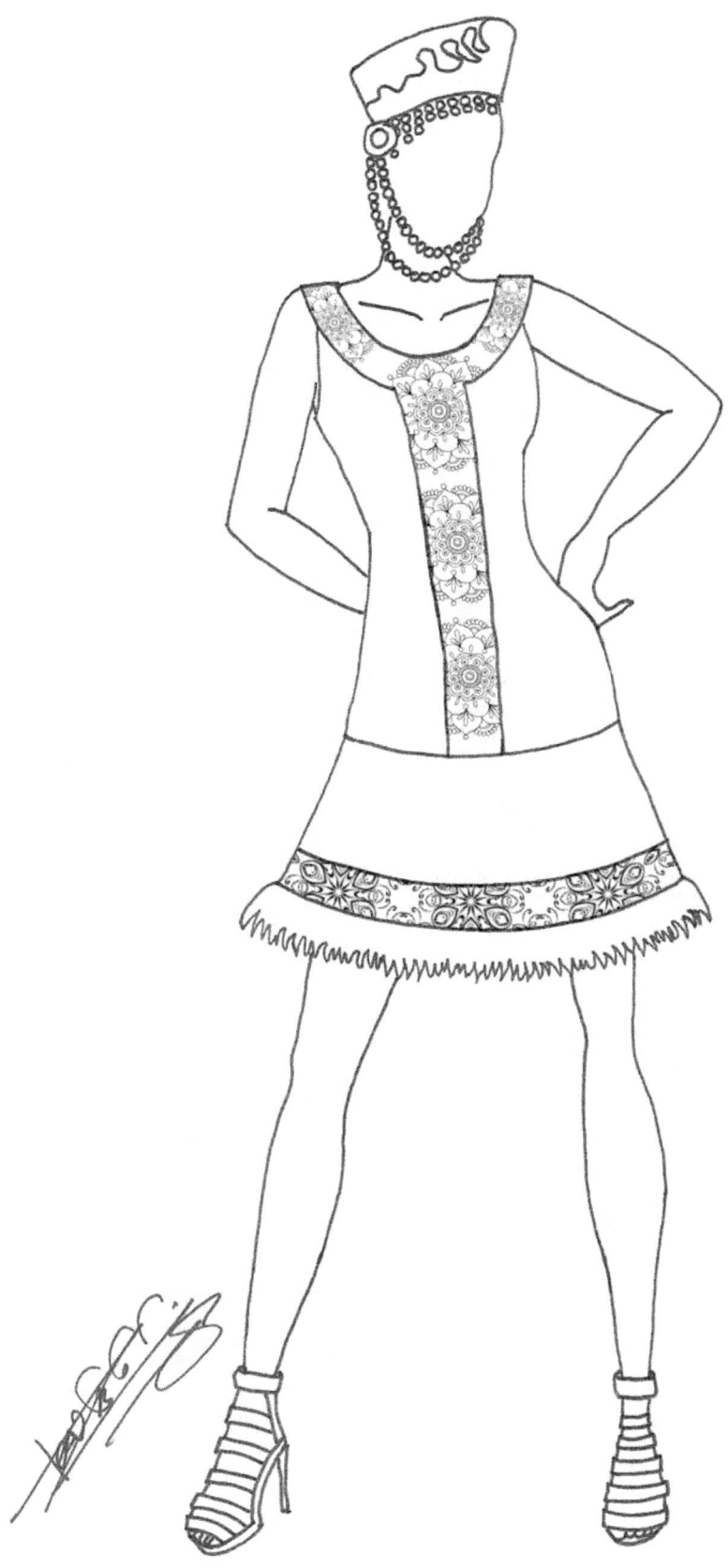

Russia

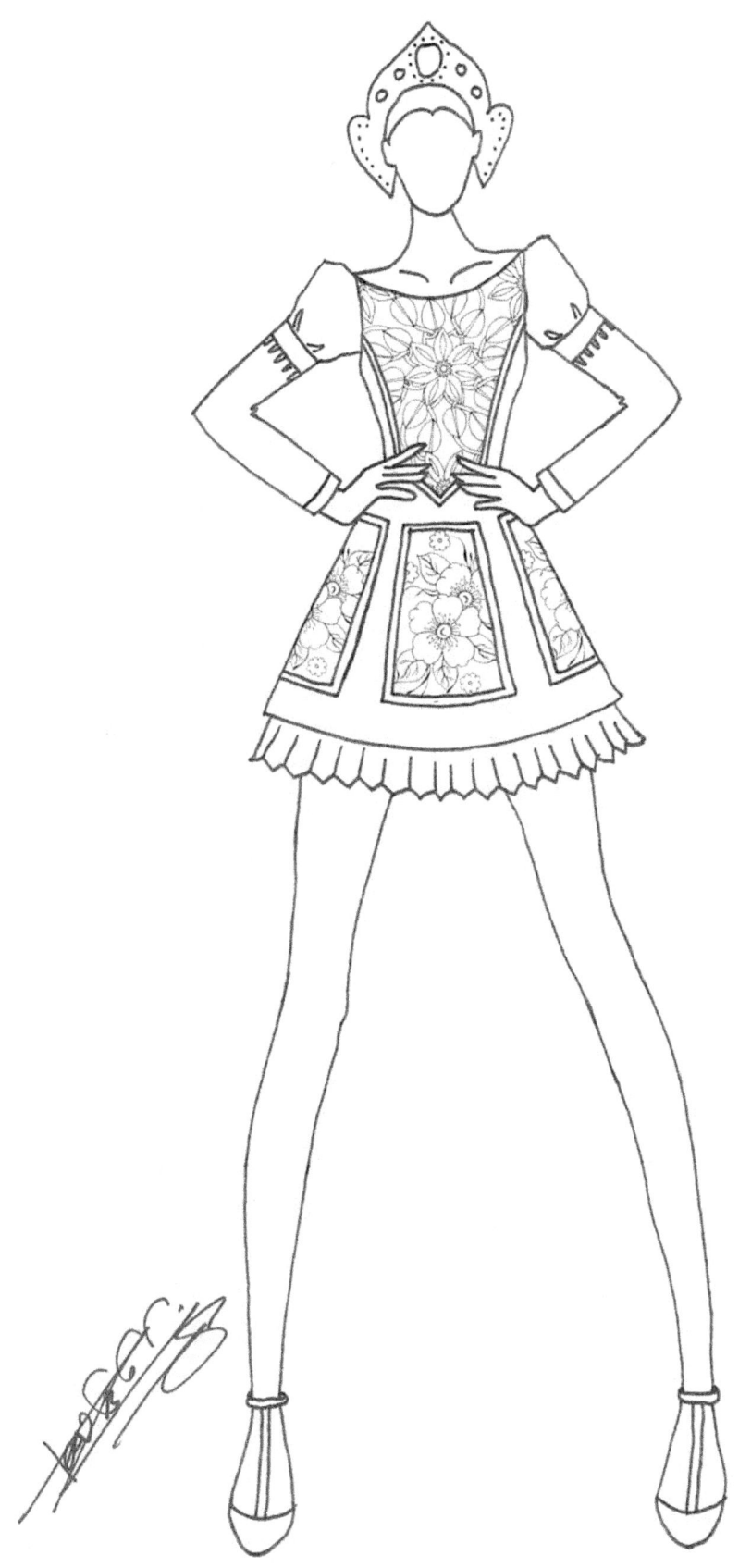

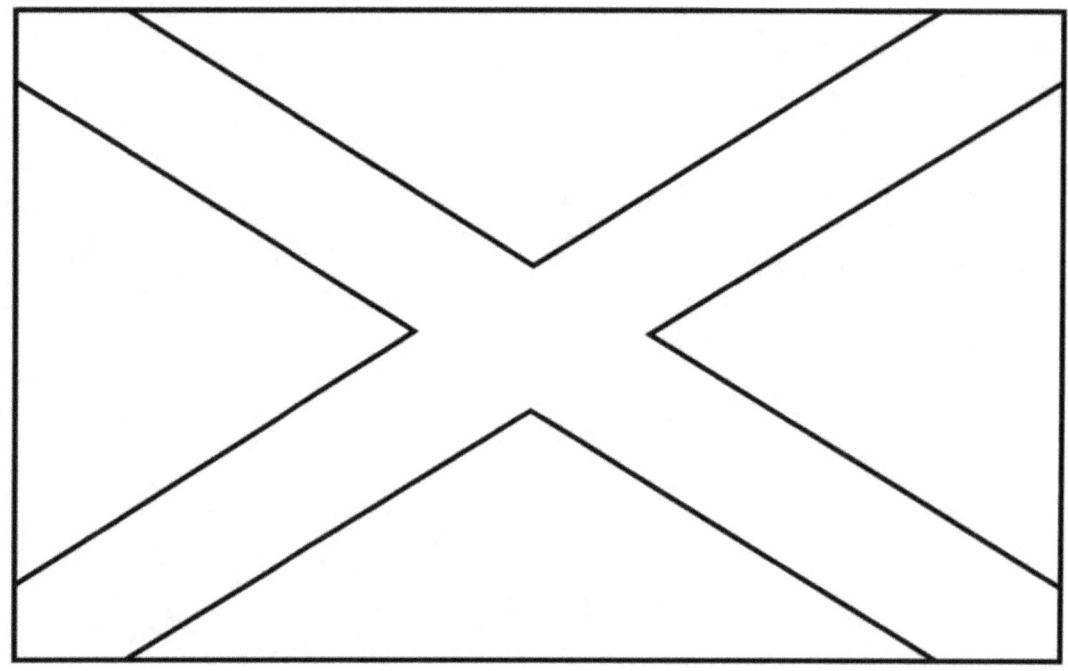

Scotland

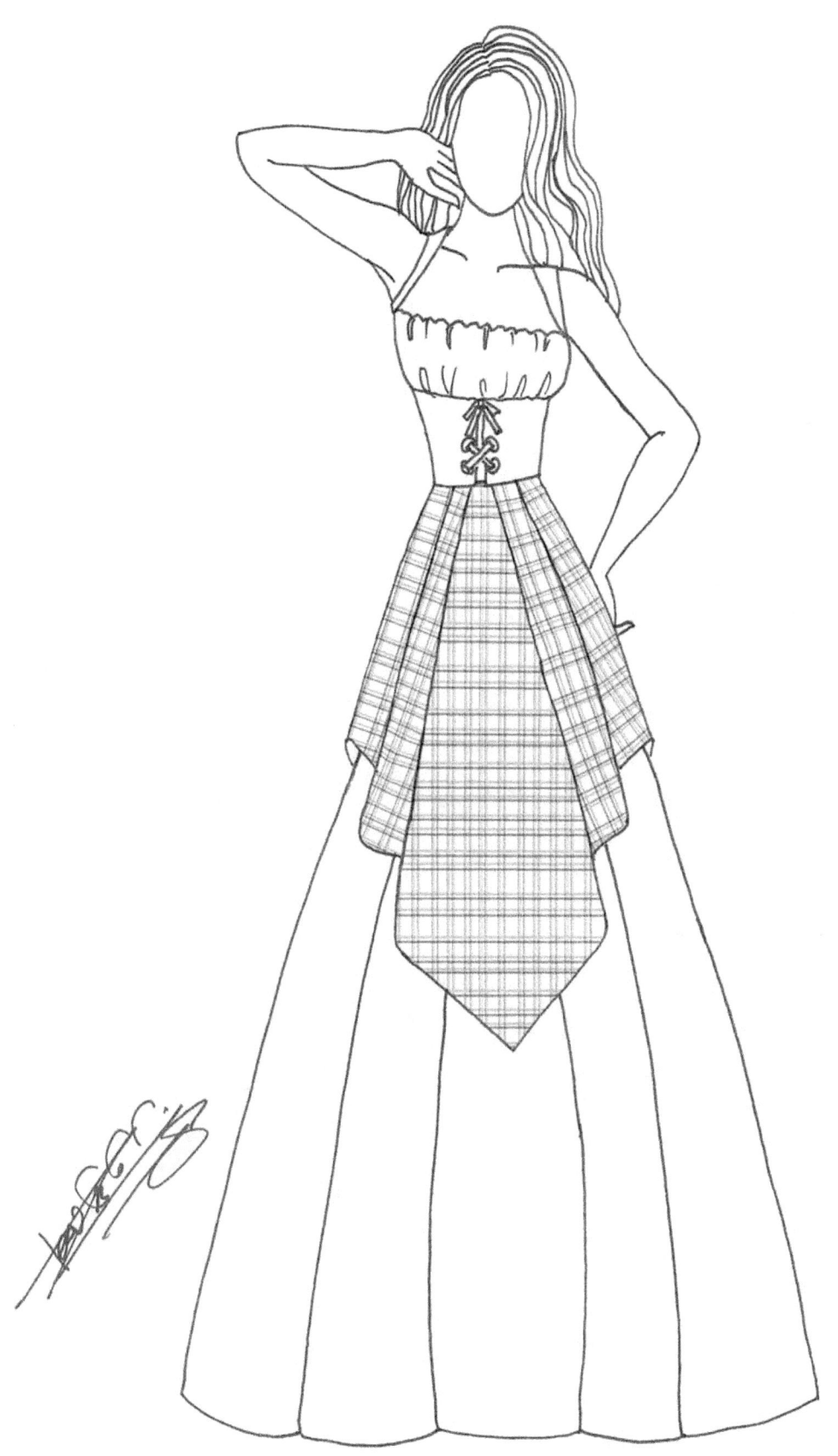

Poland

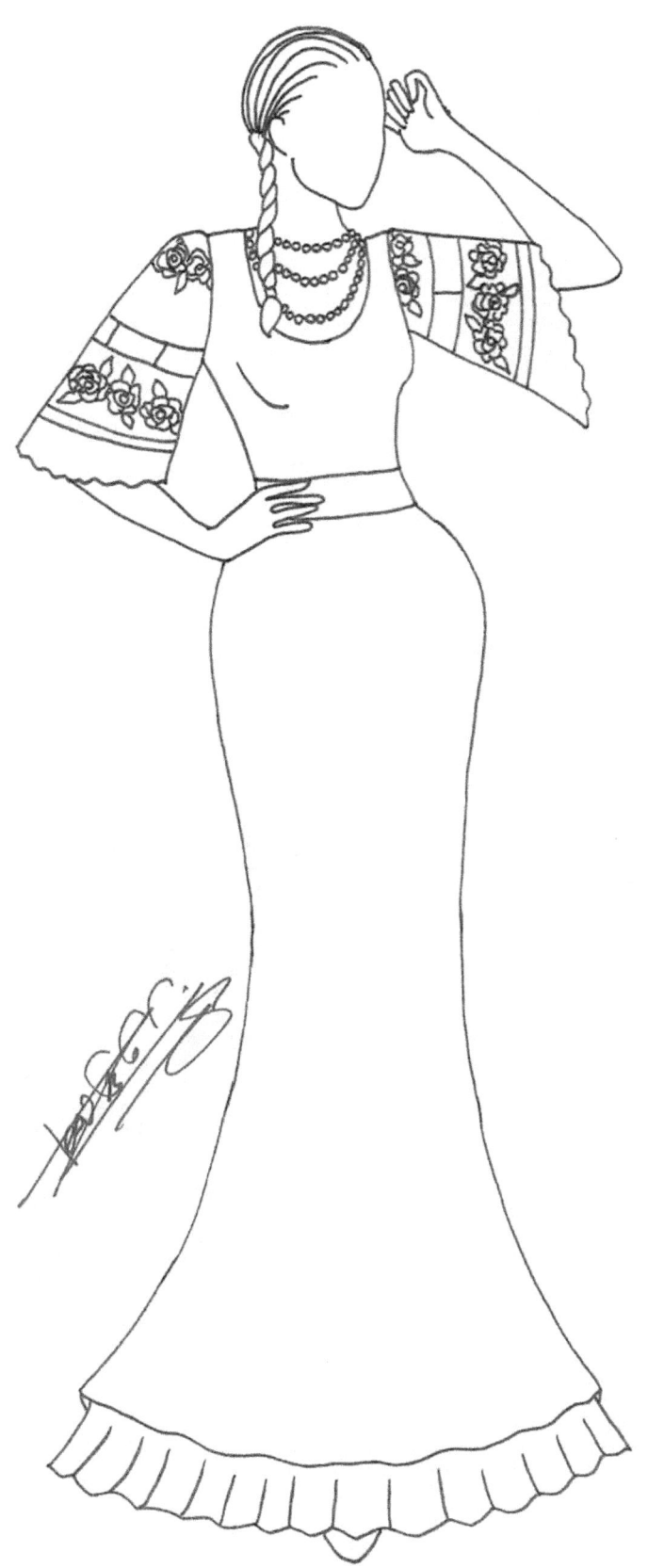

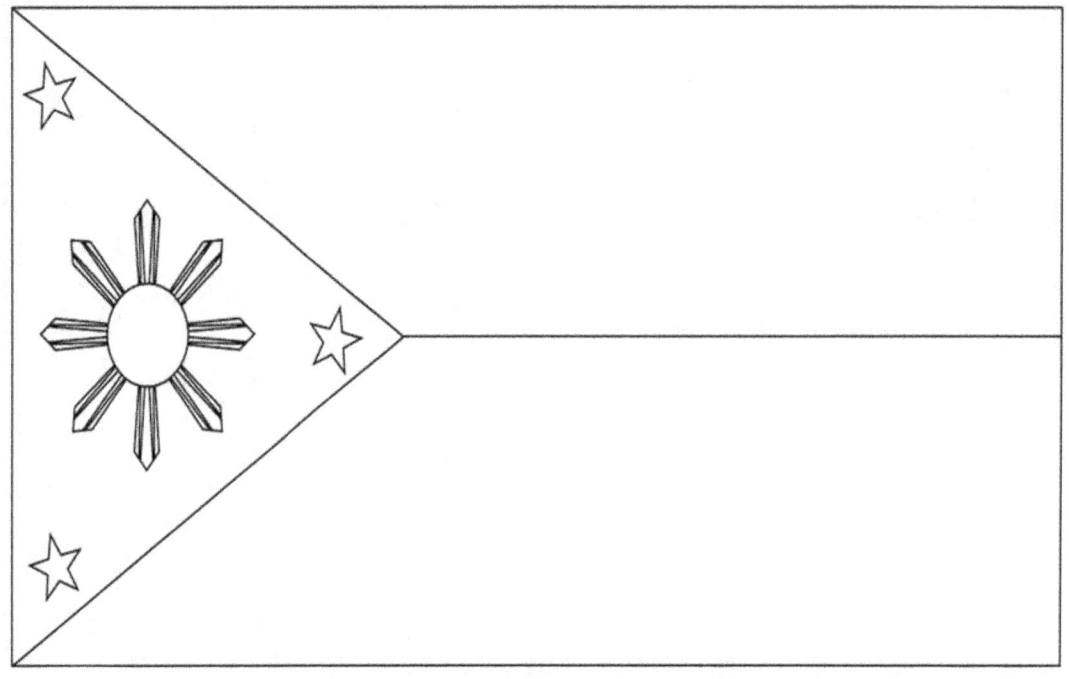

Philippines

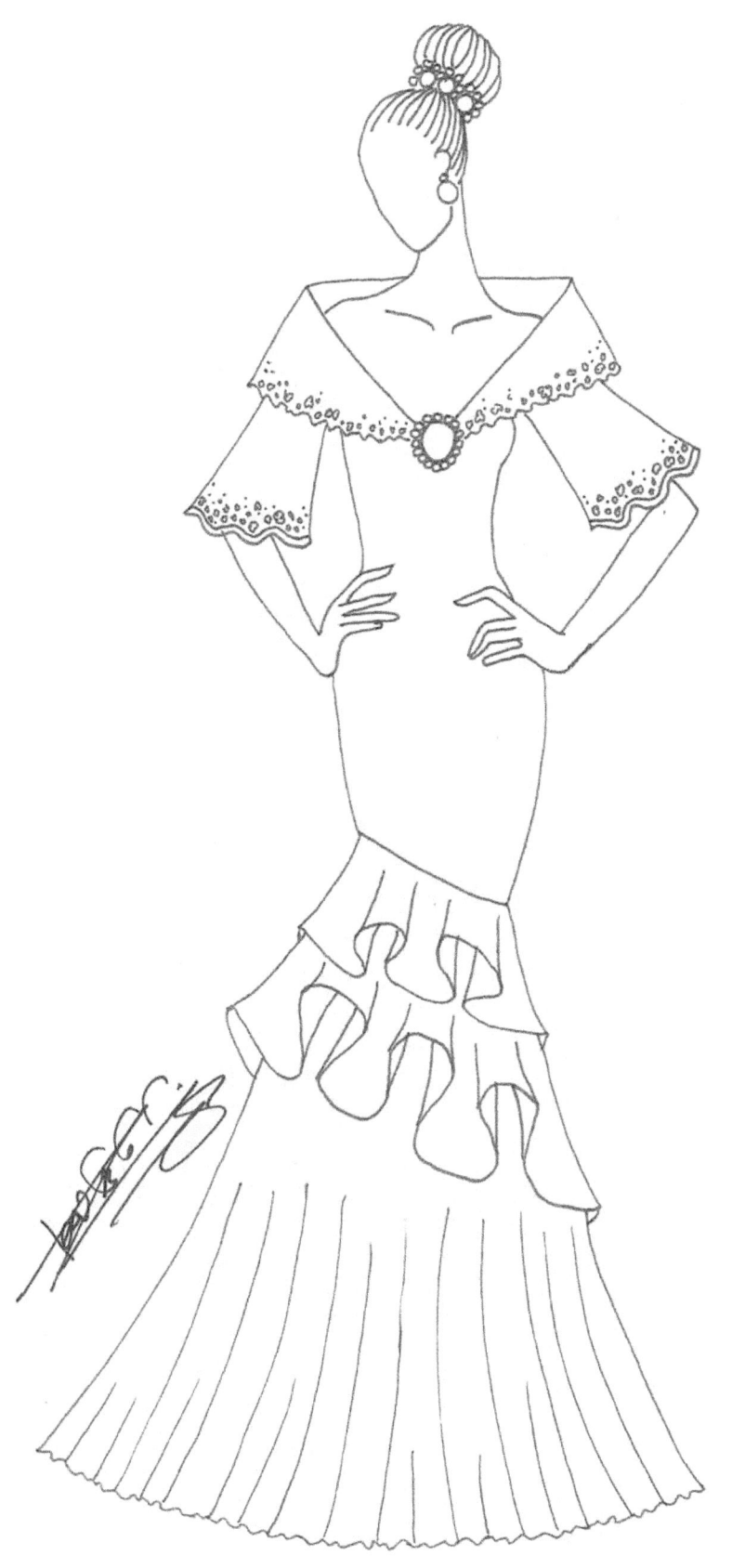

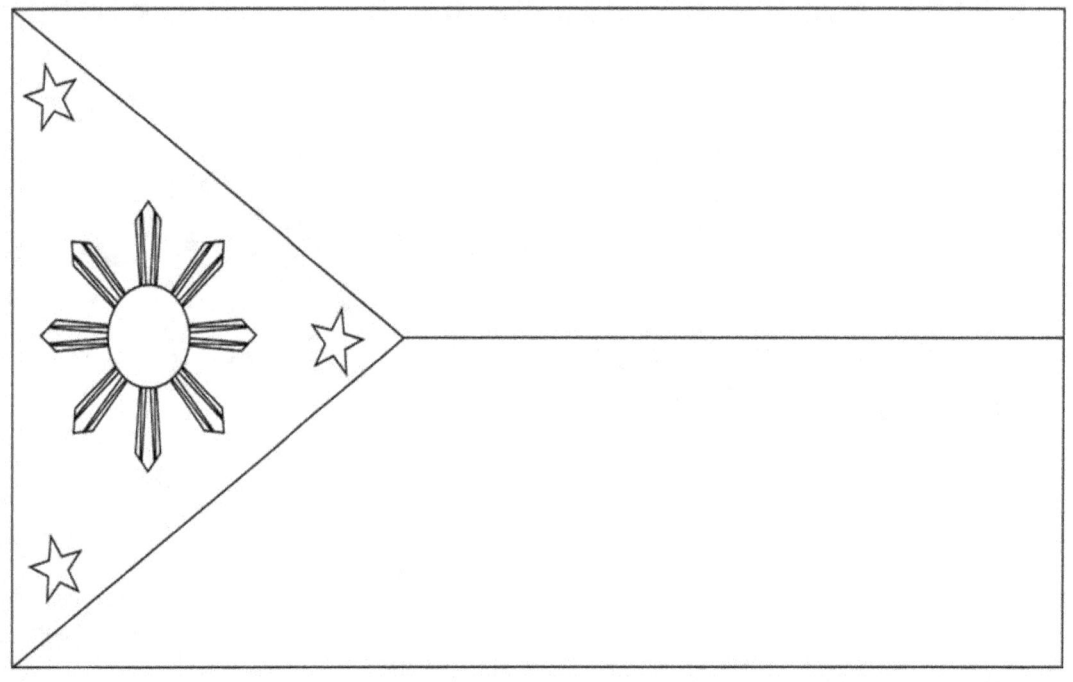

Philippines

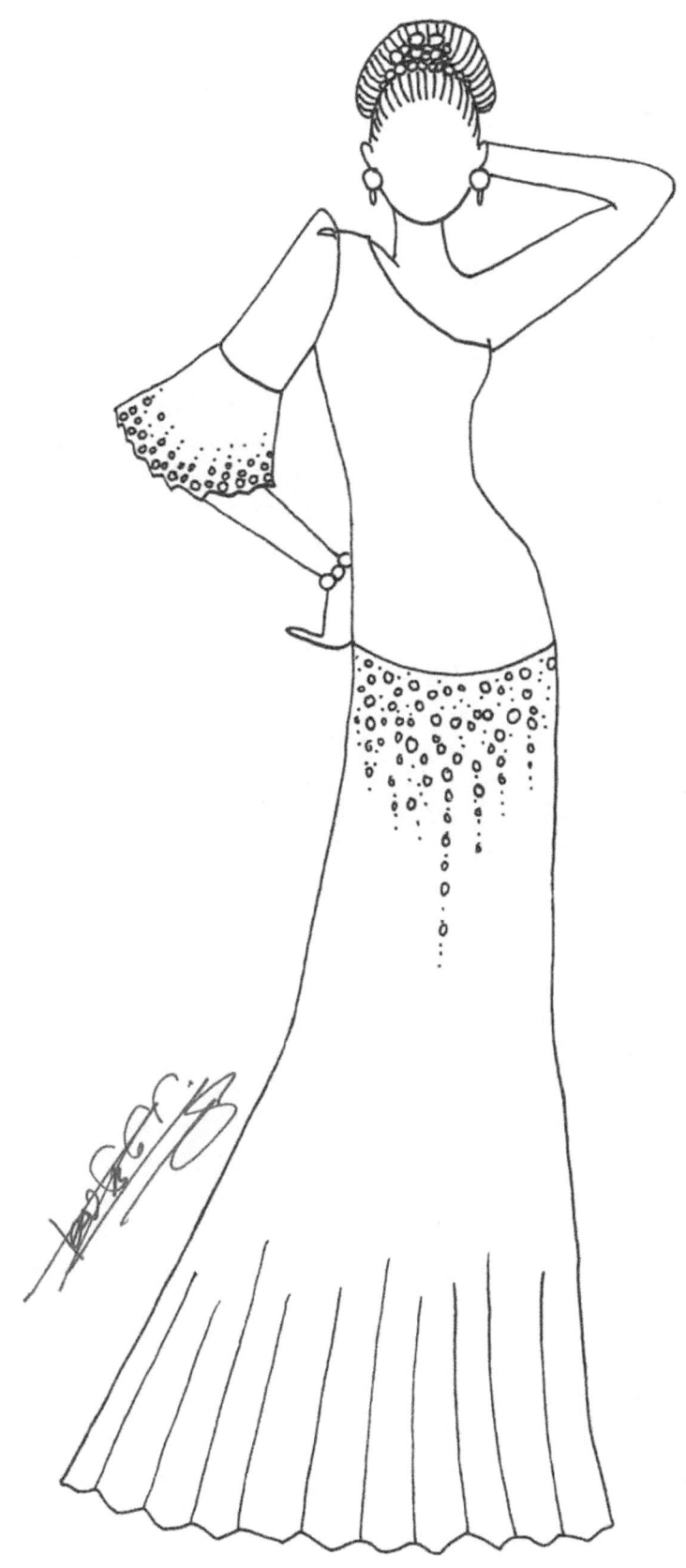

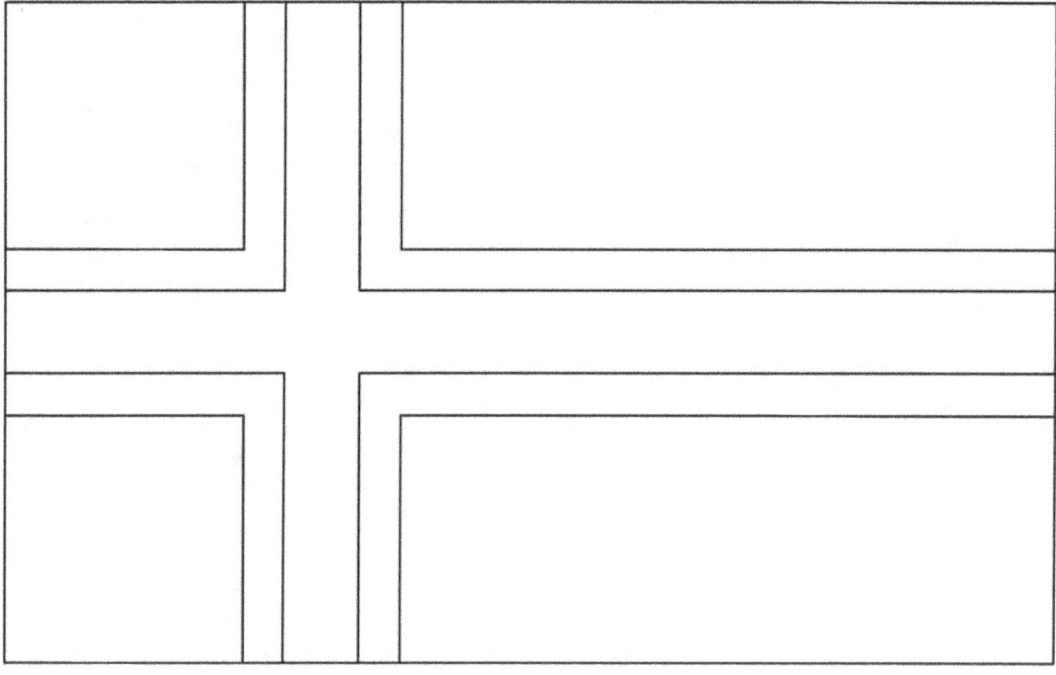

Norway

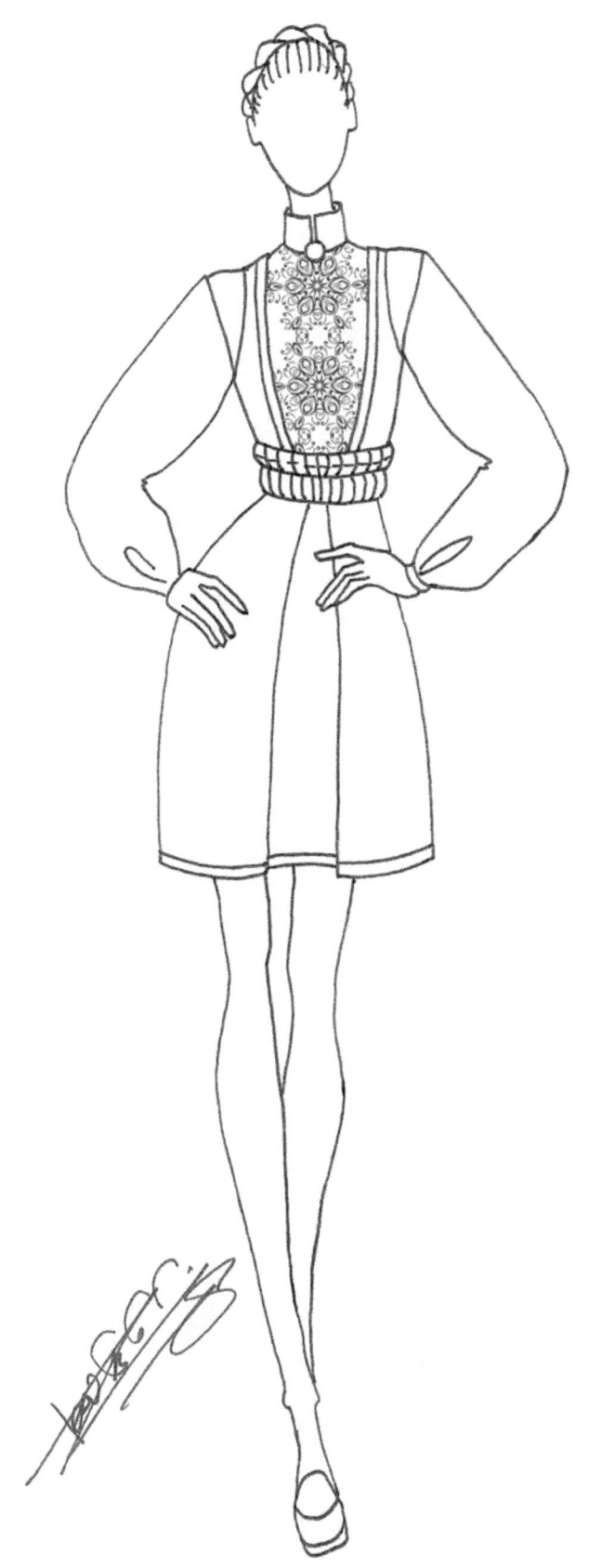

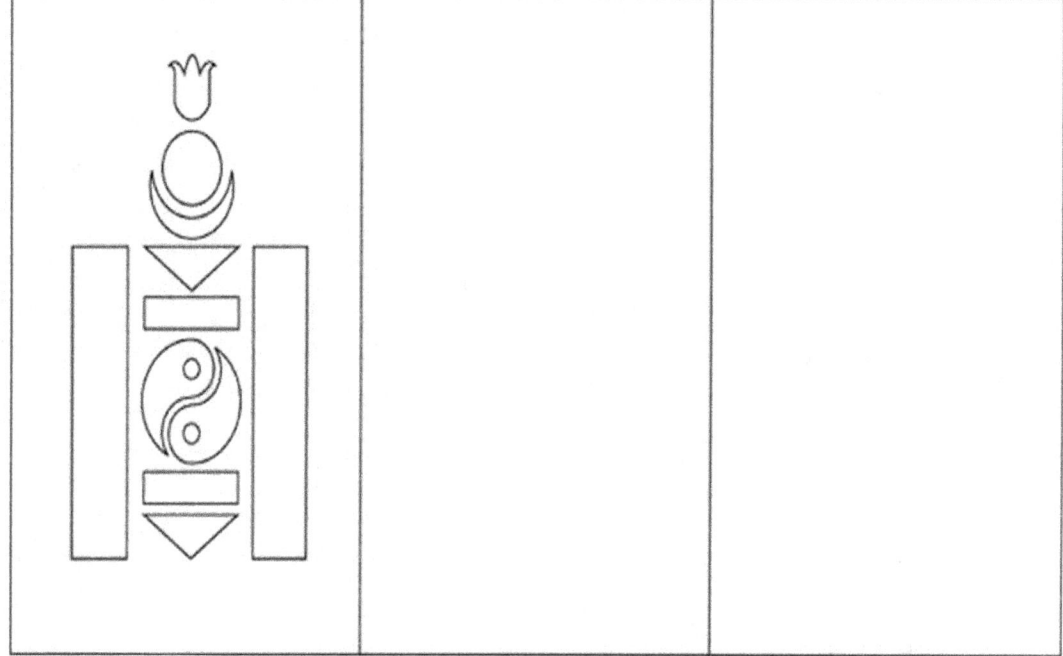

Mongolia

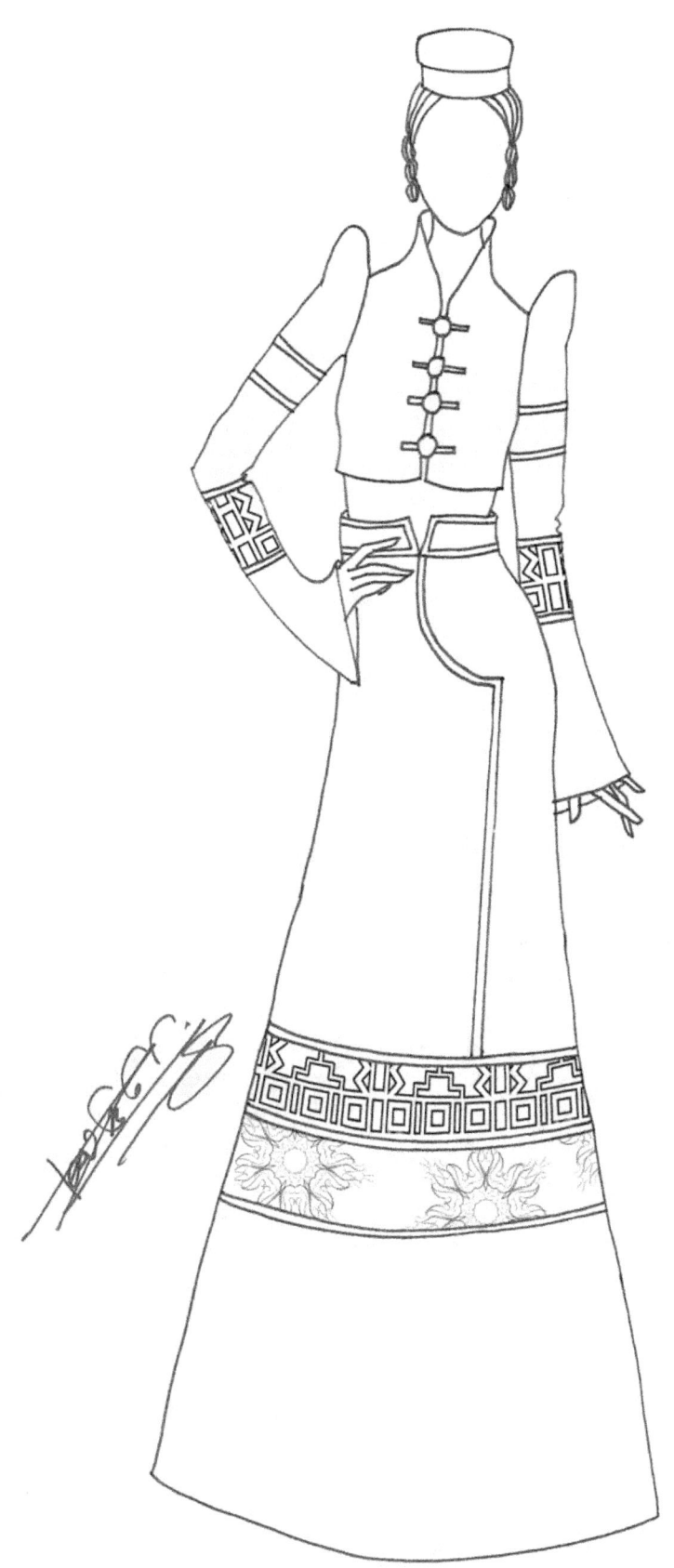

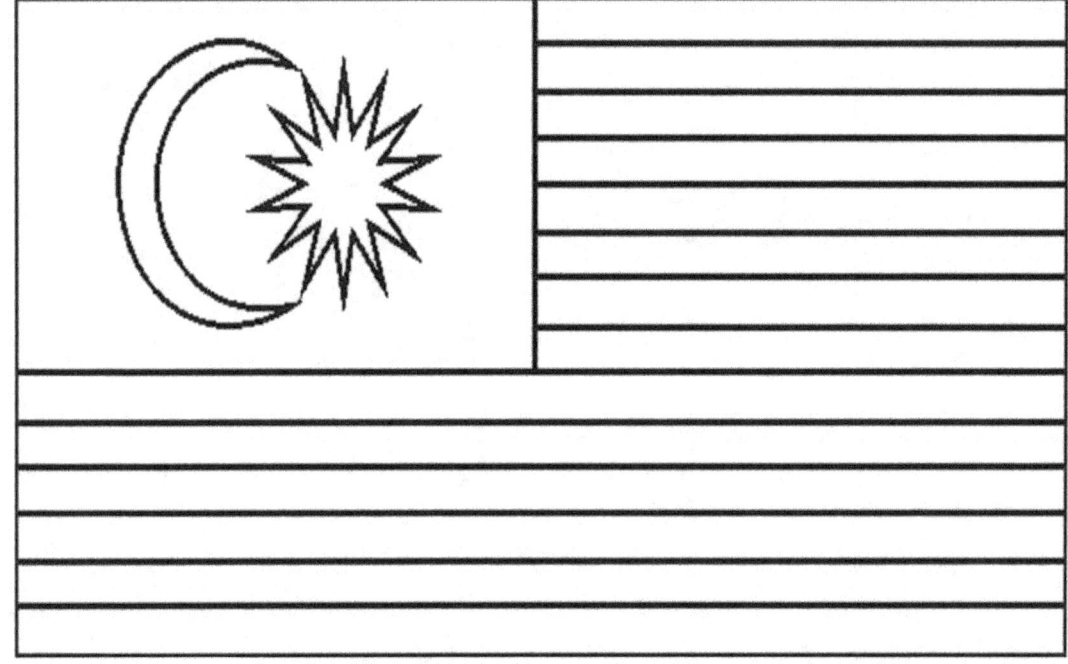

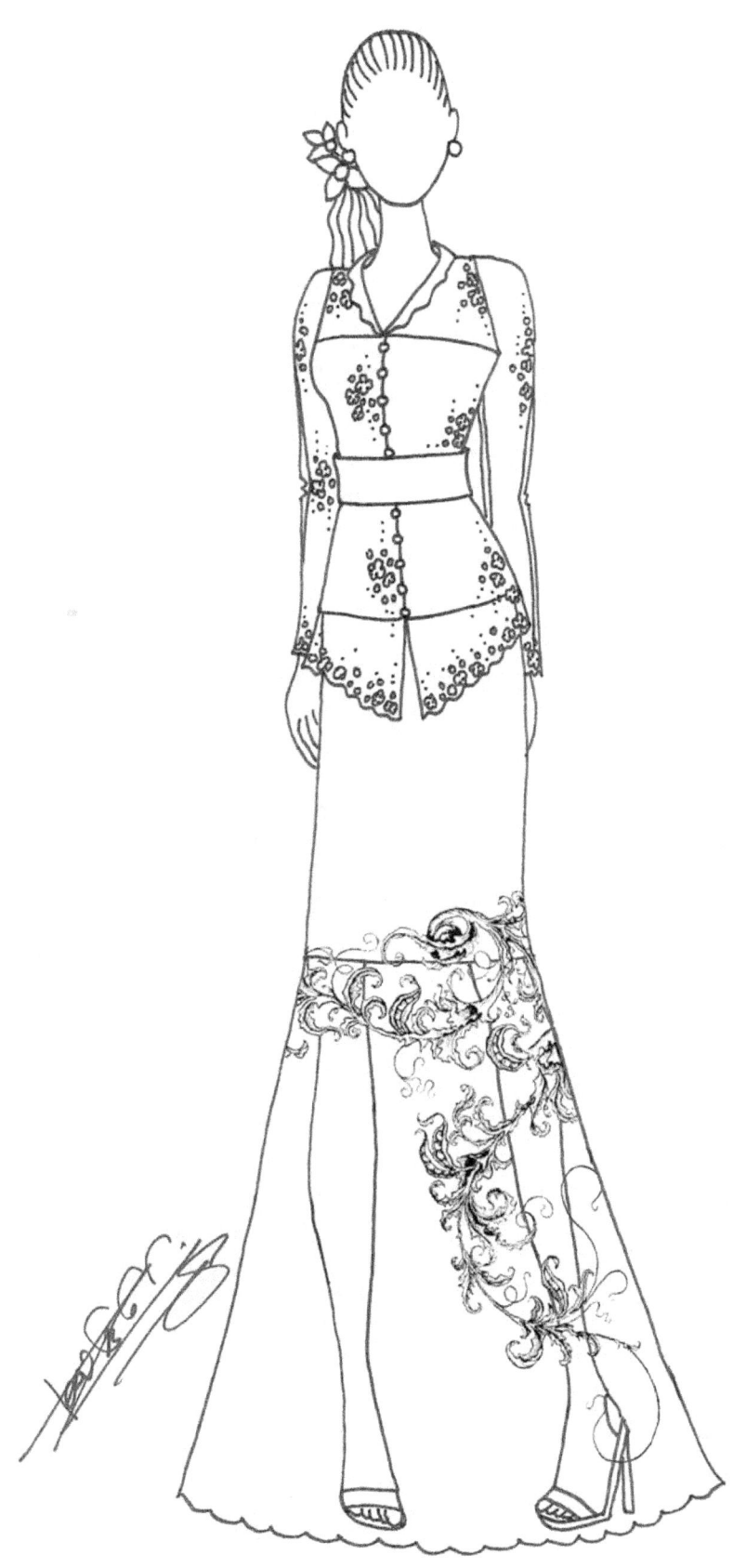

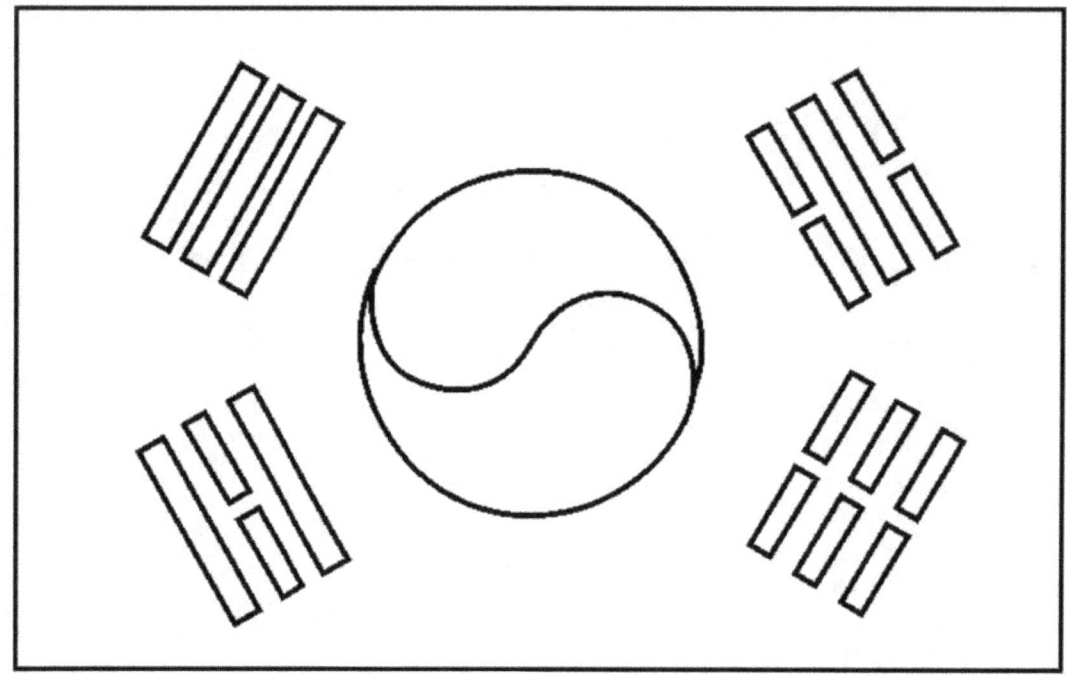

South Korea

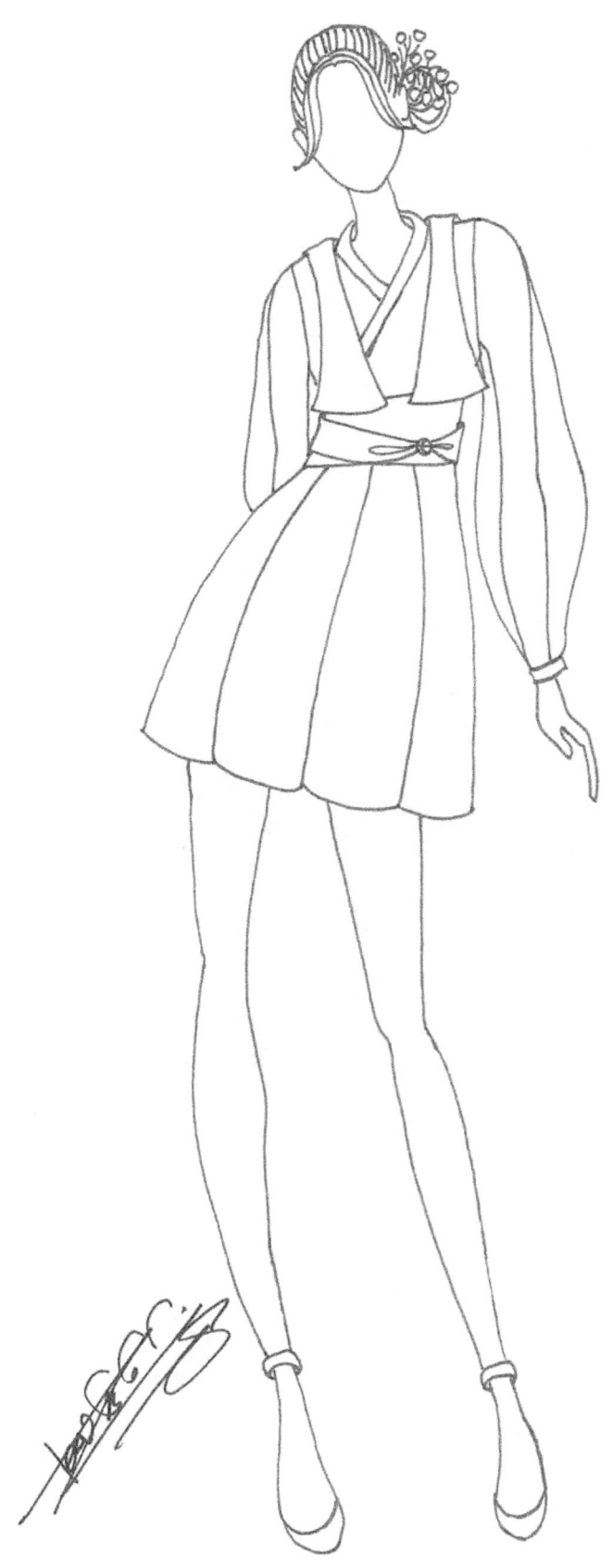

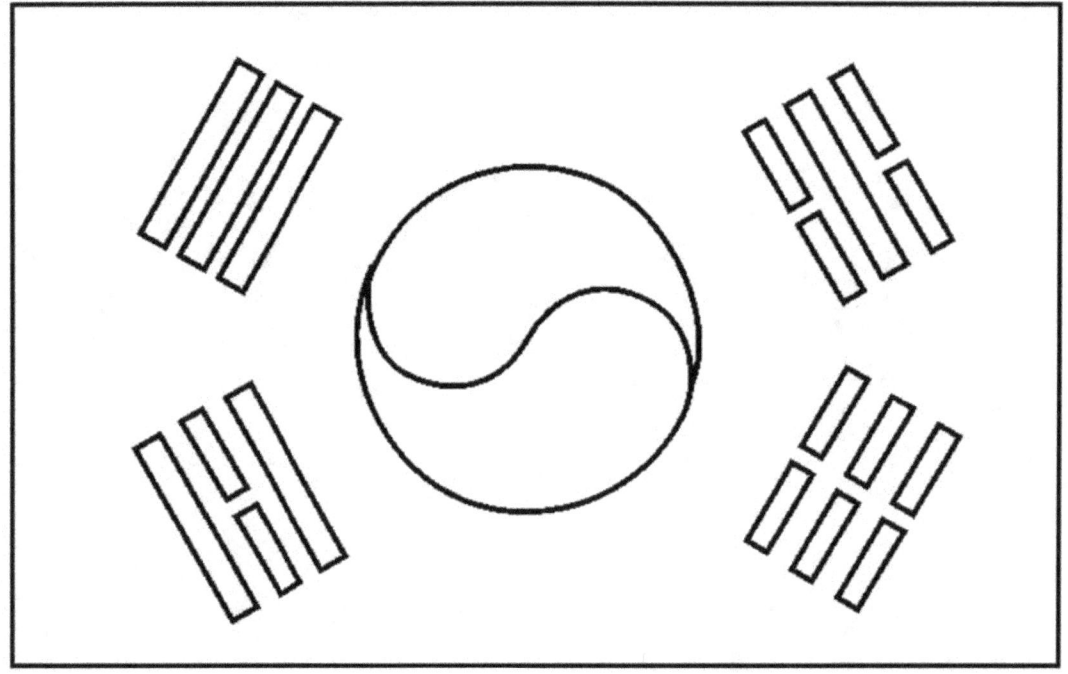

South Korea

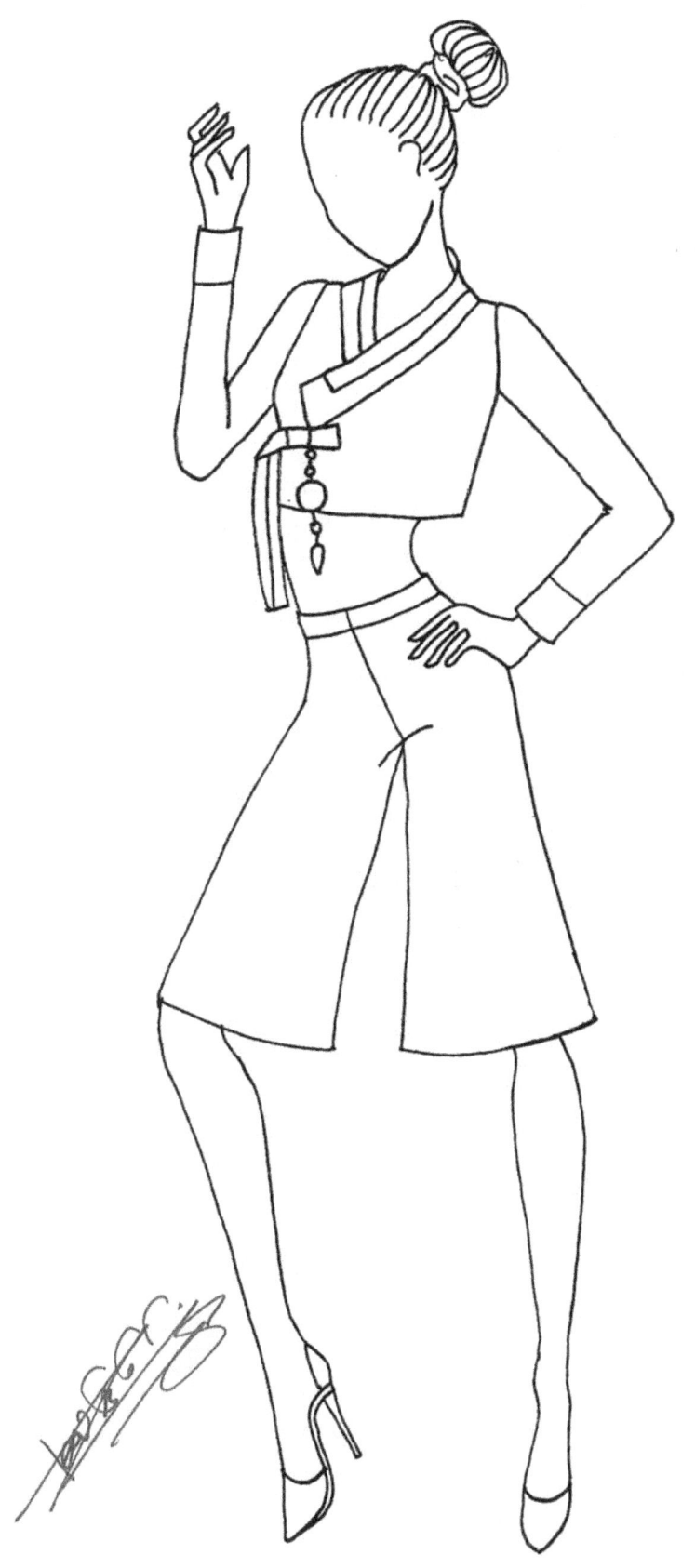

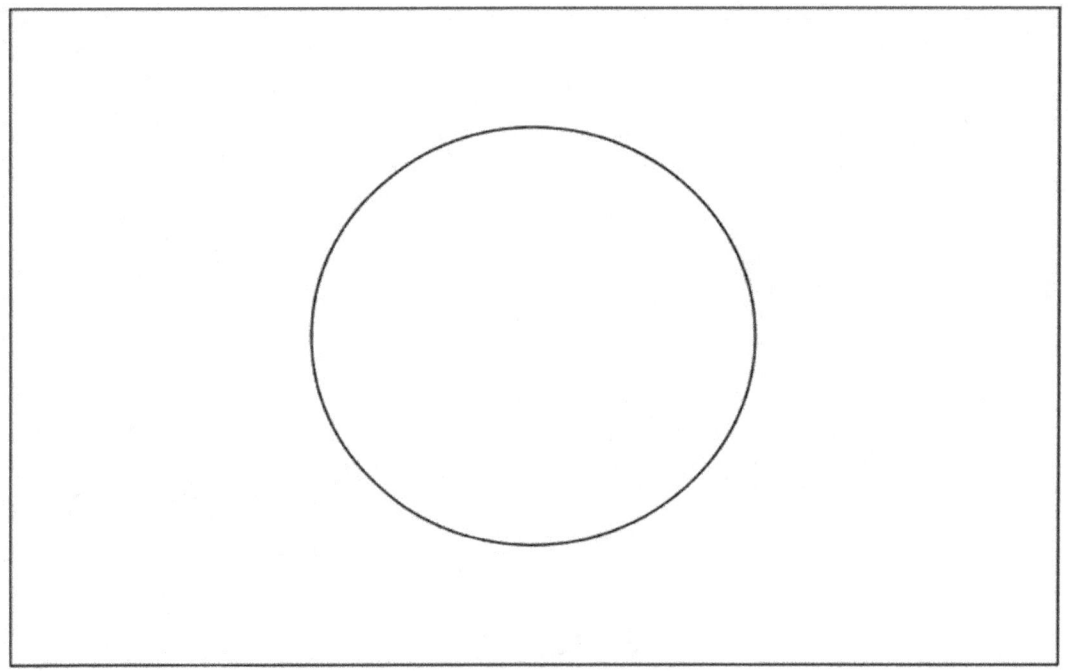

Japan

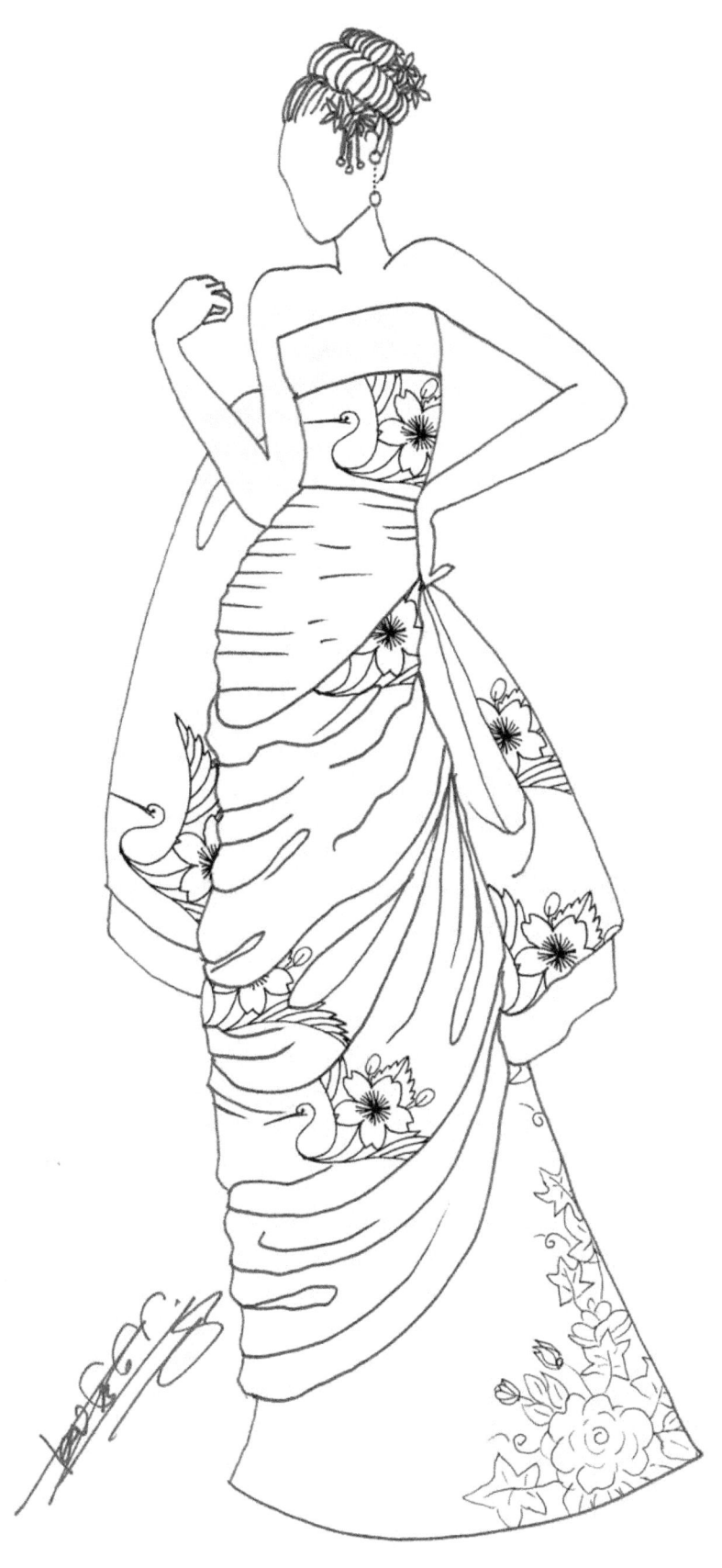

Japan

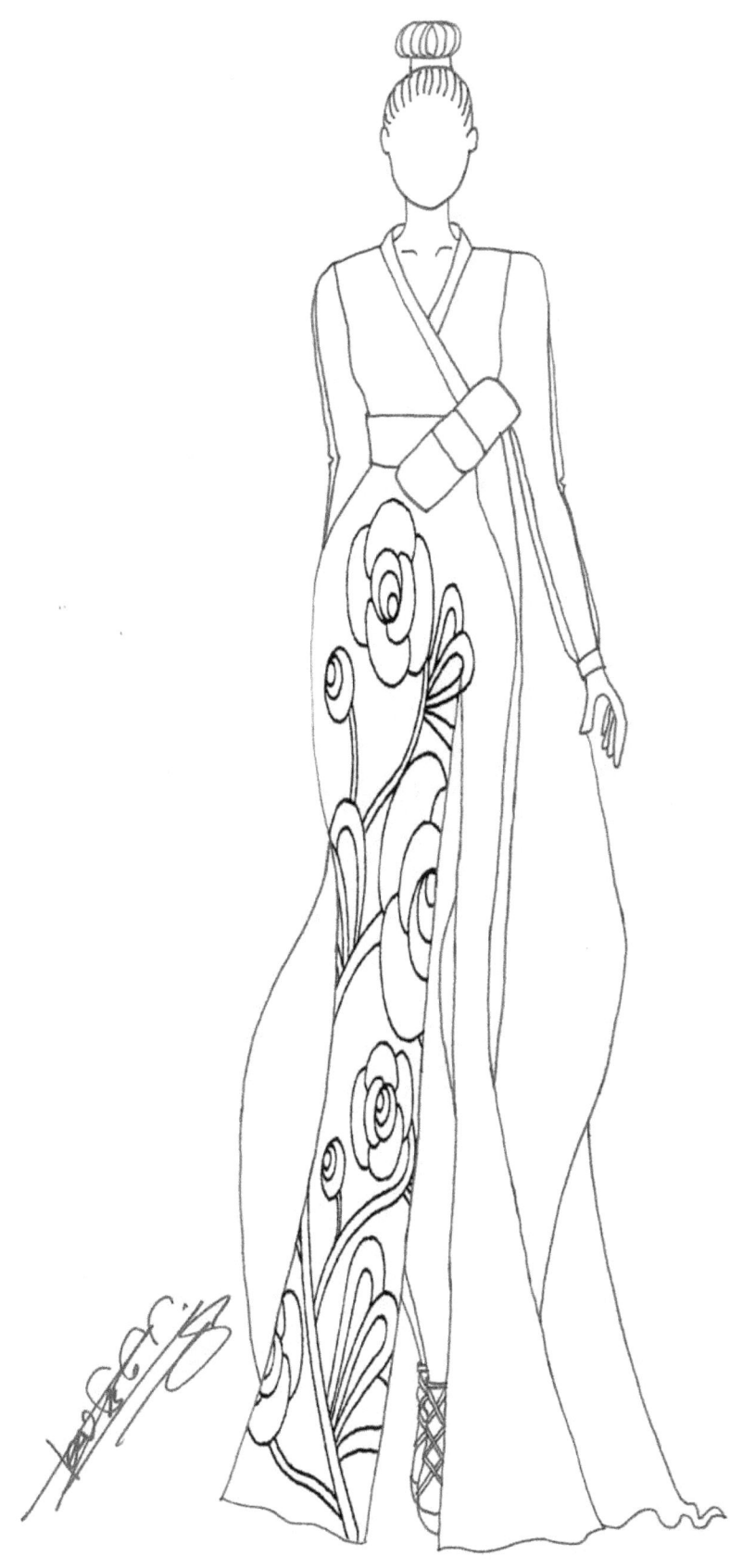

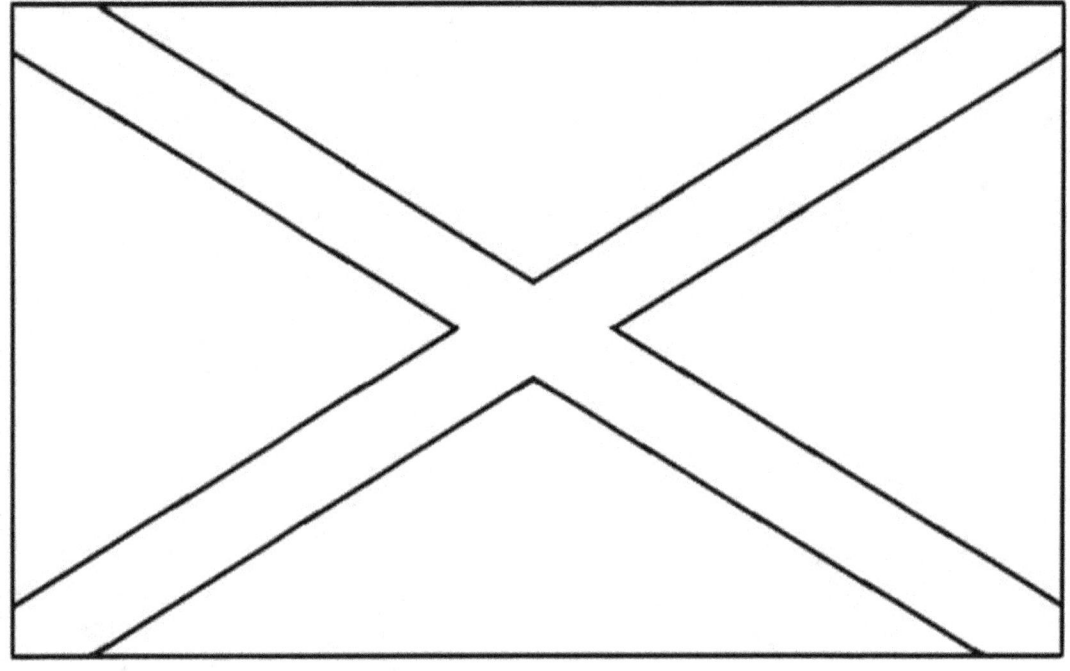

Jamaica

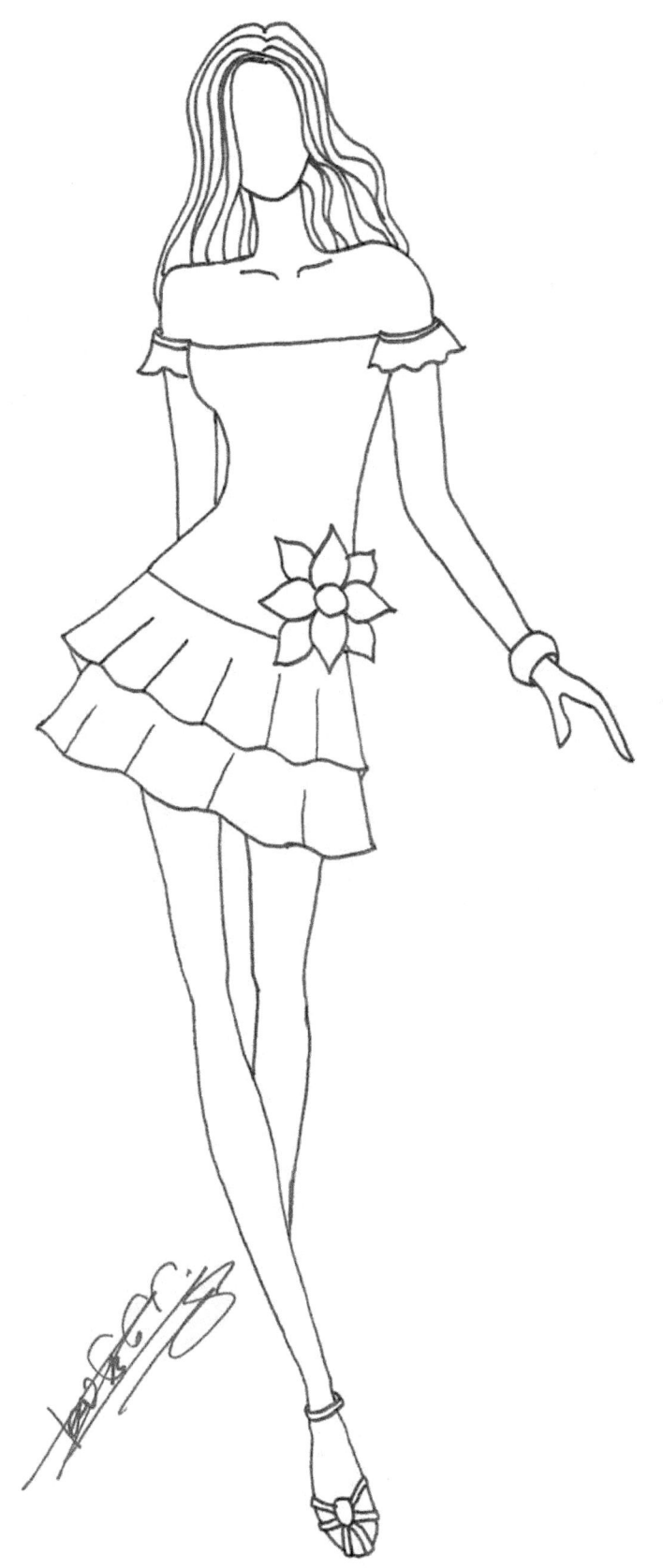

Indonesia

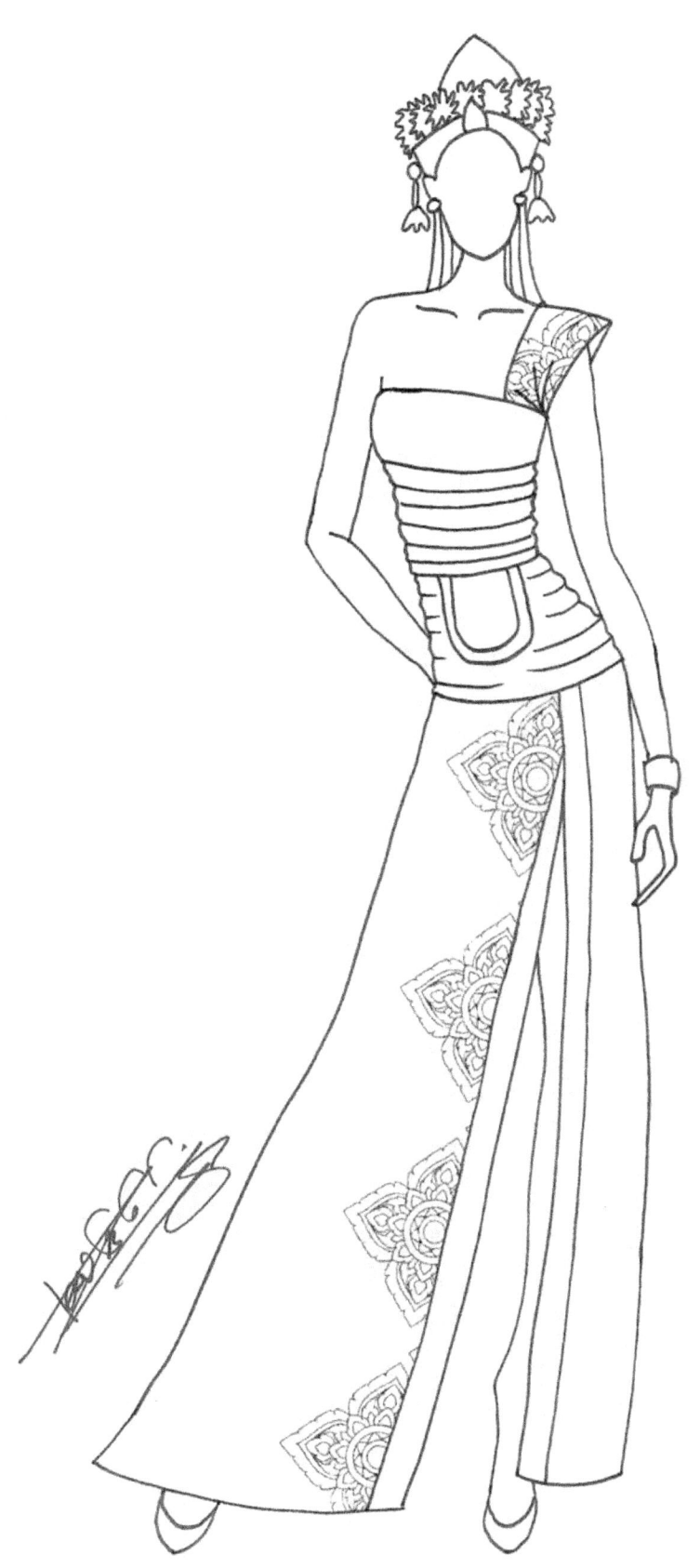

Indonesia

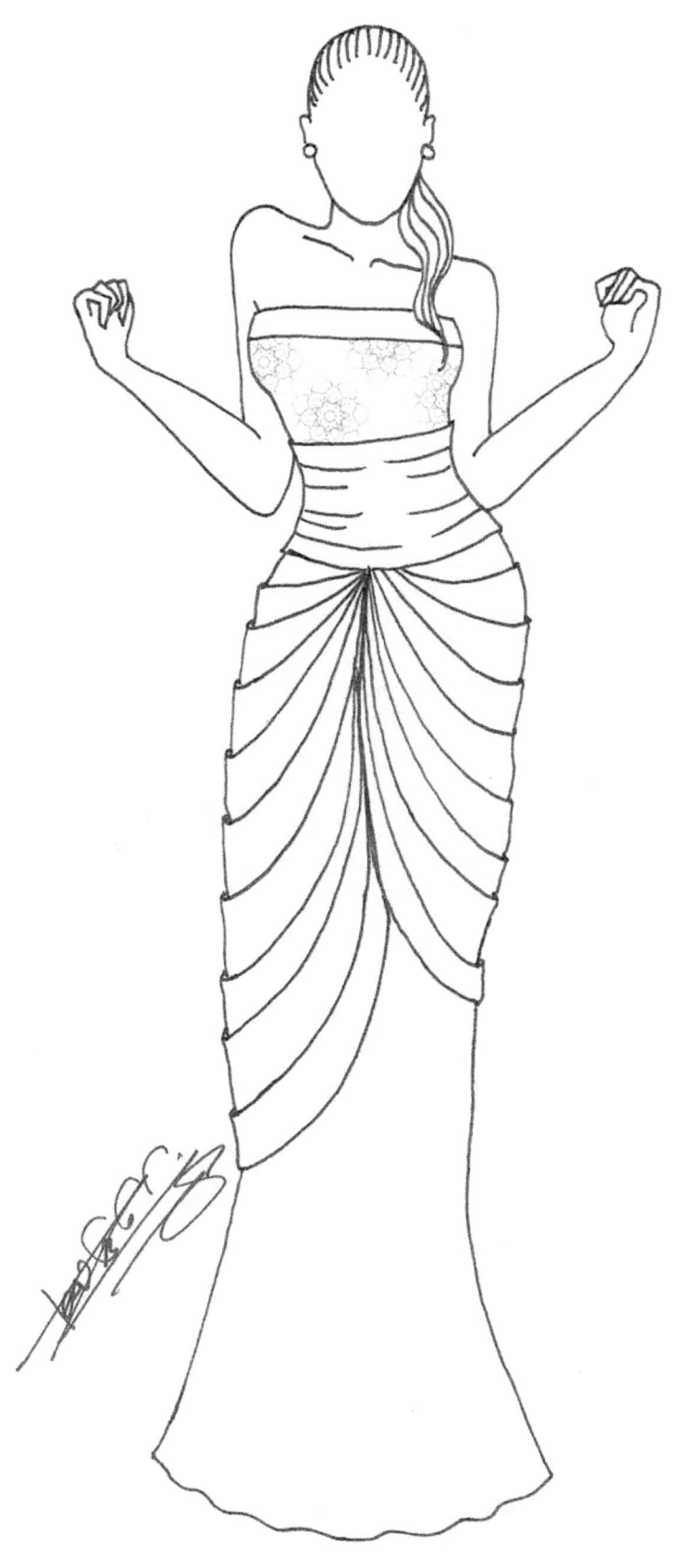

India

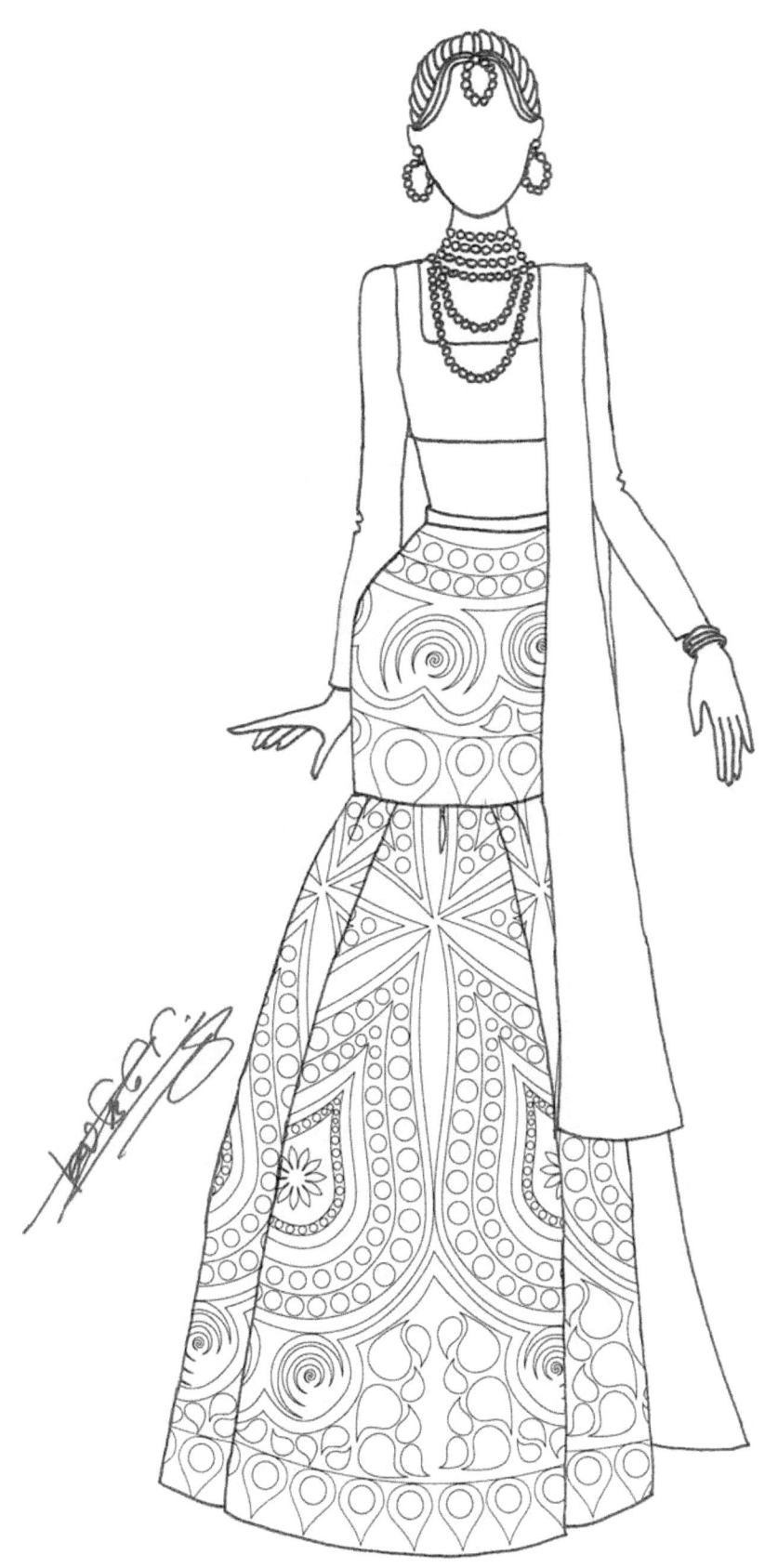

India

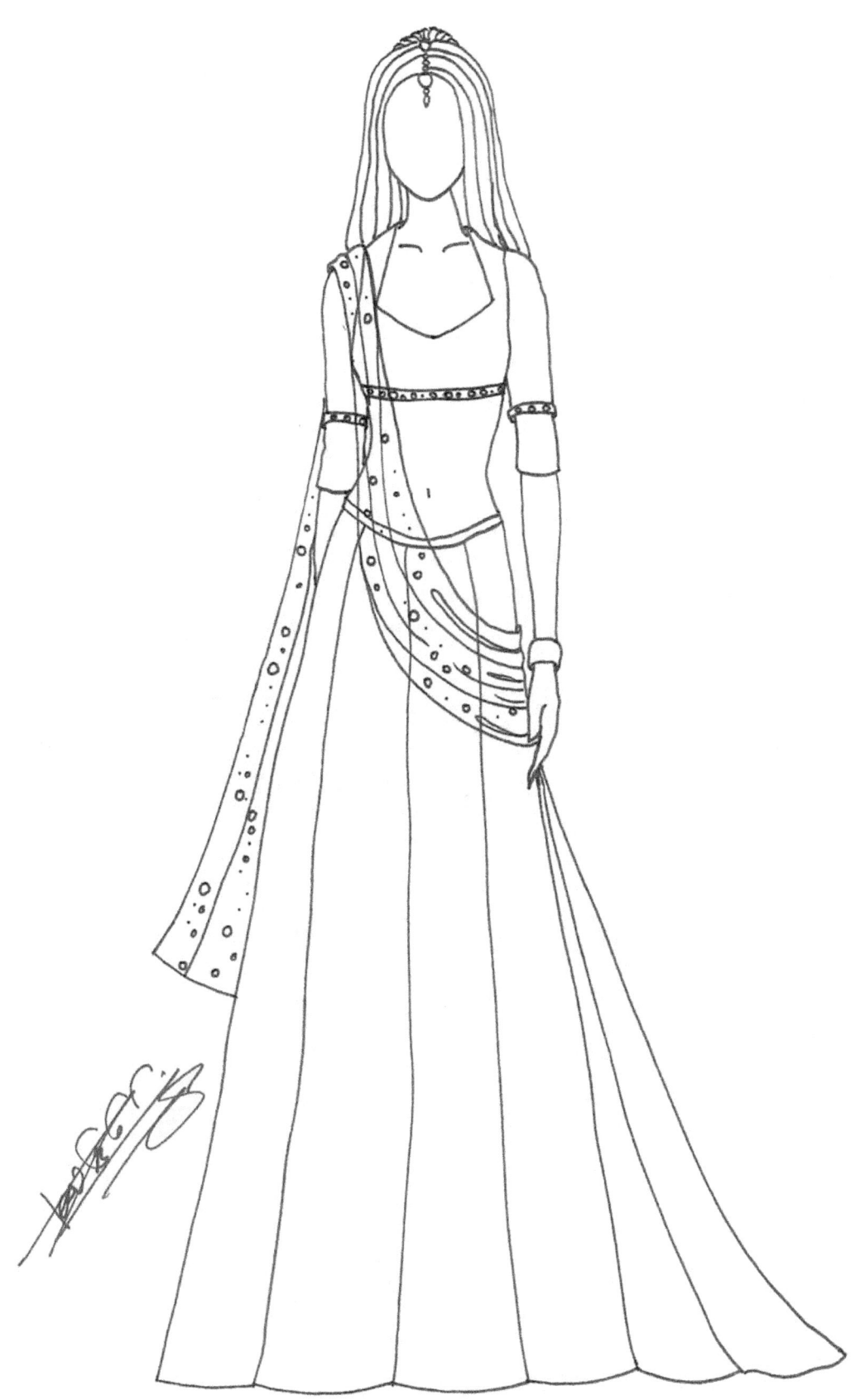

Greece

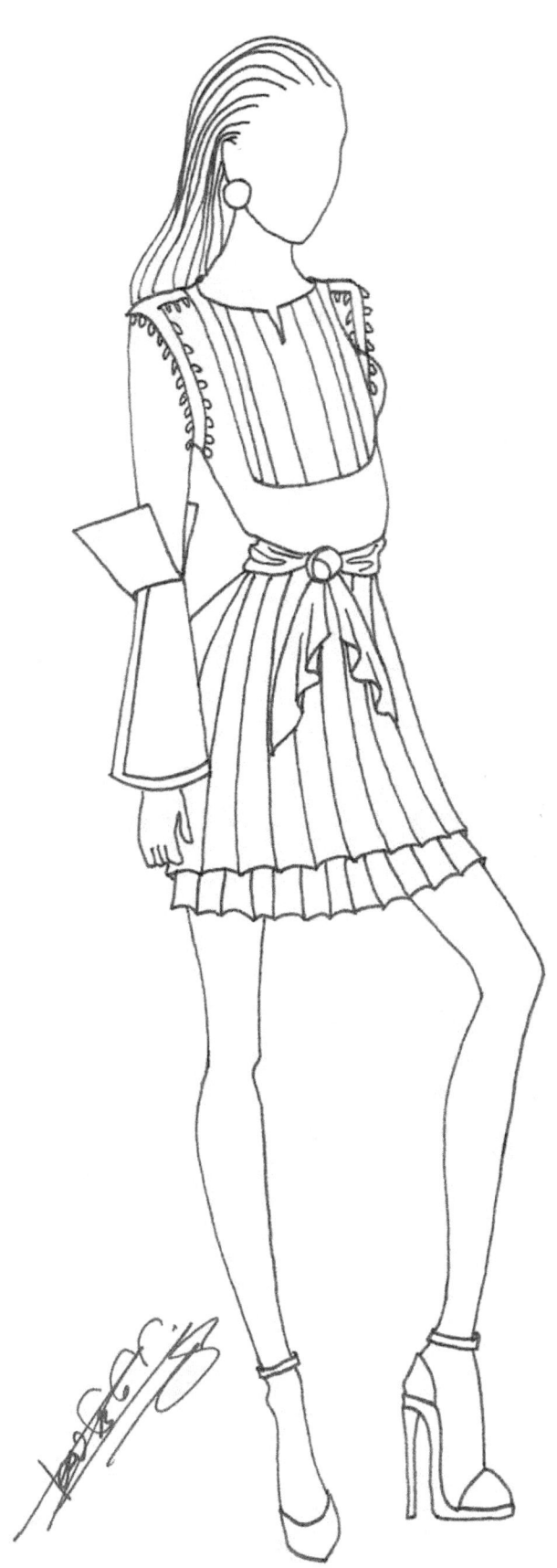

Finland

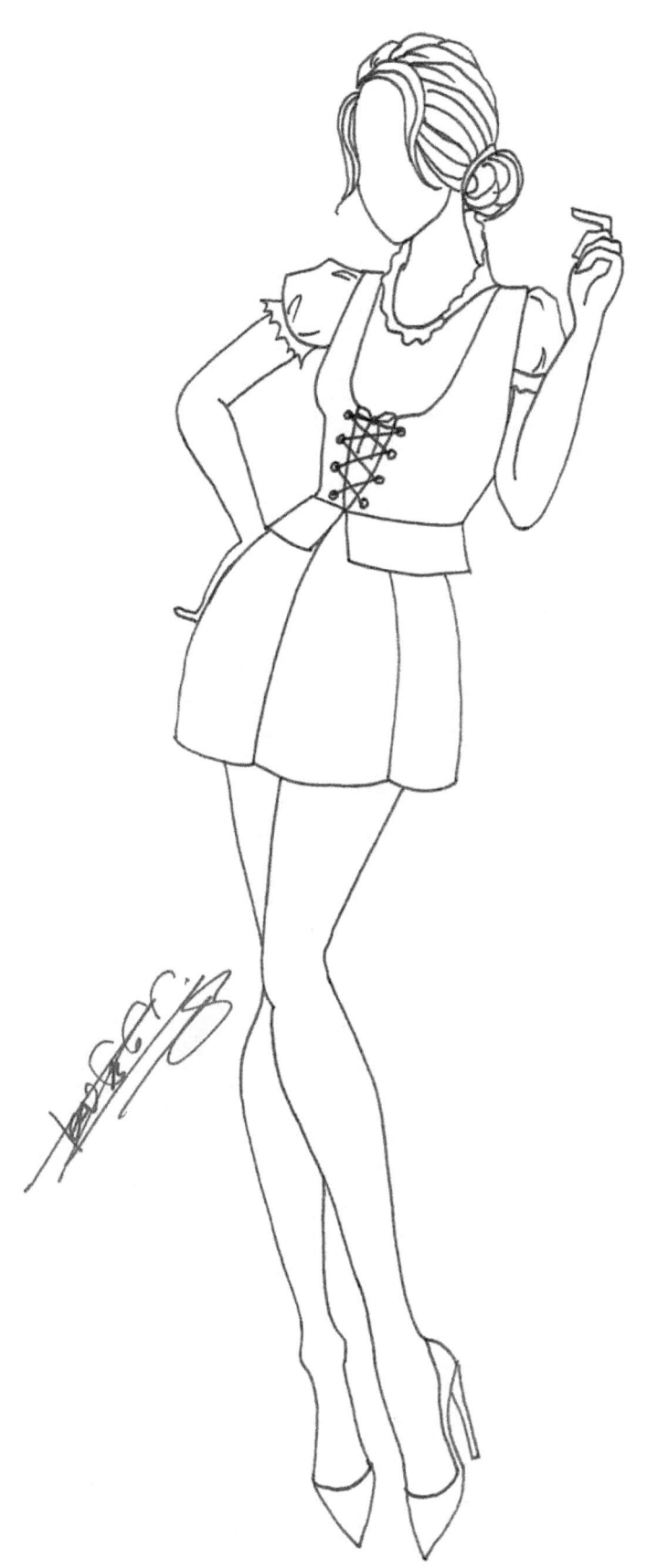

China

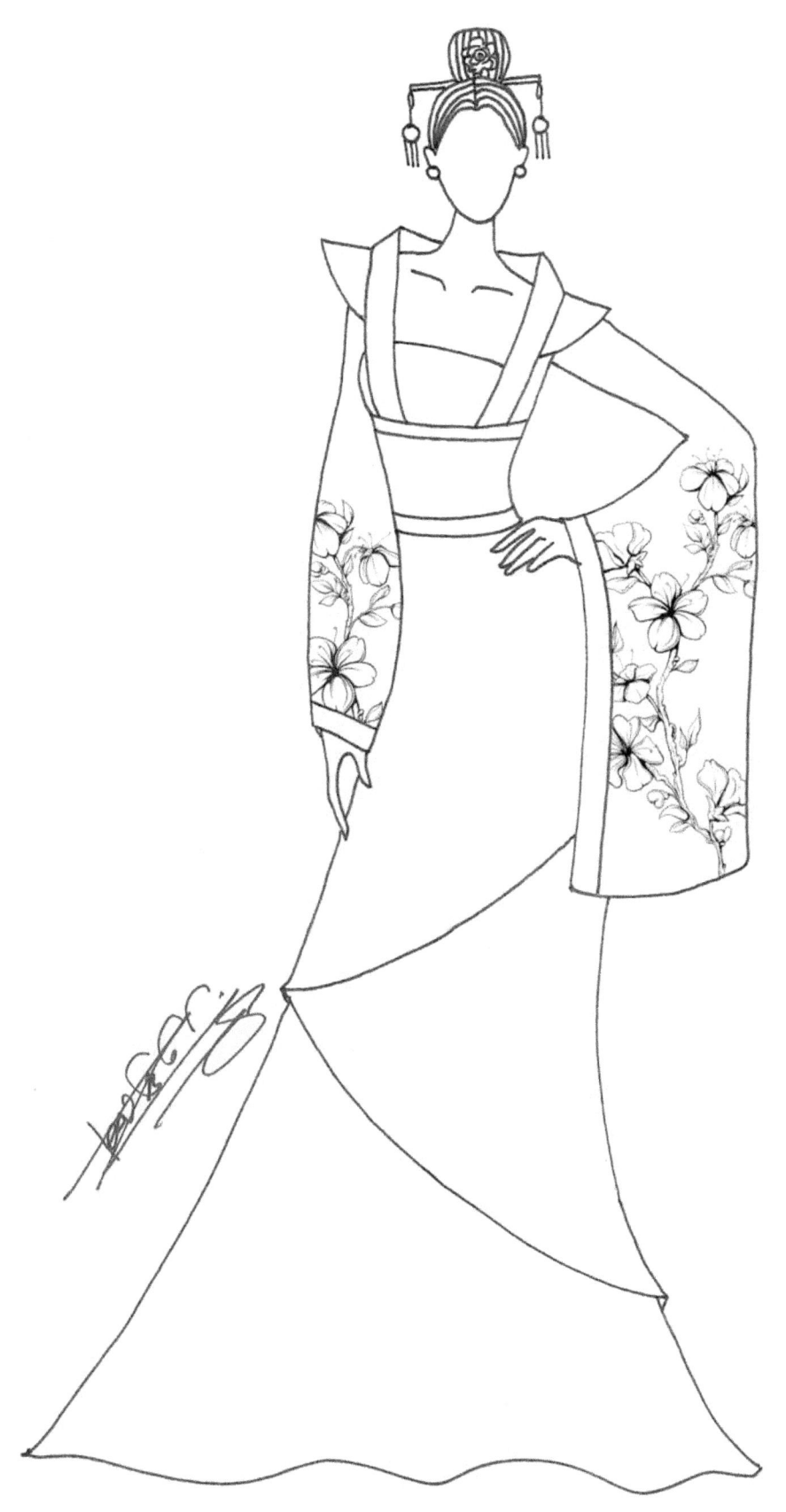

China

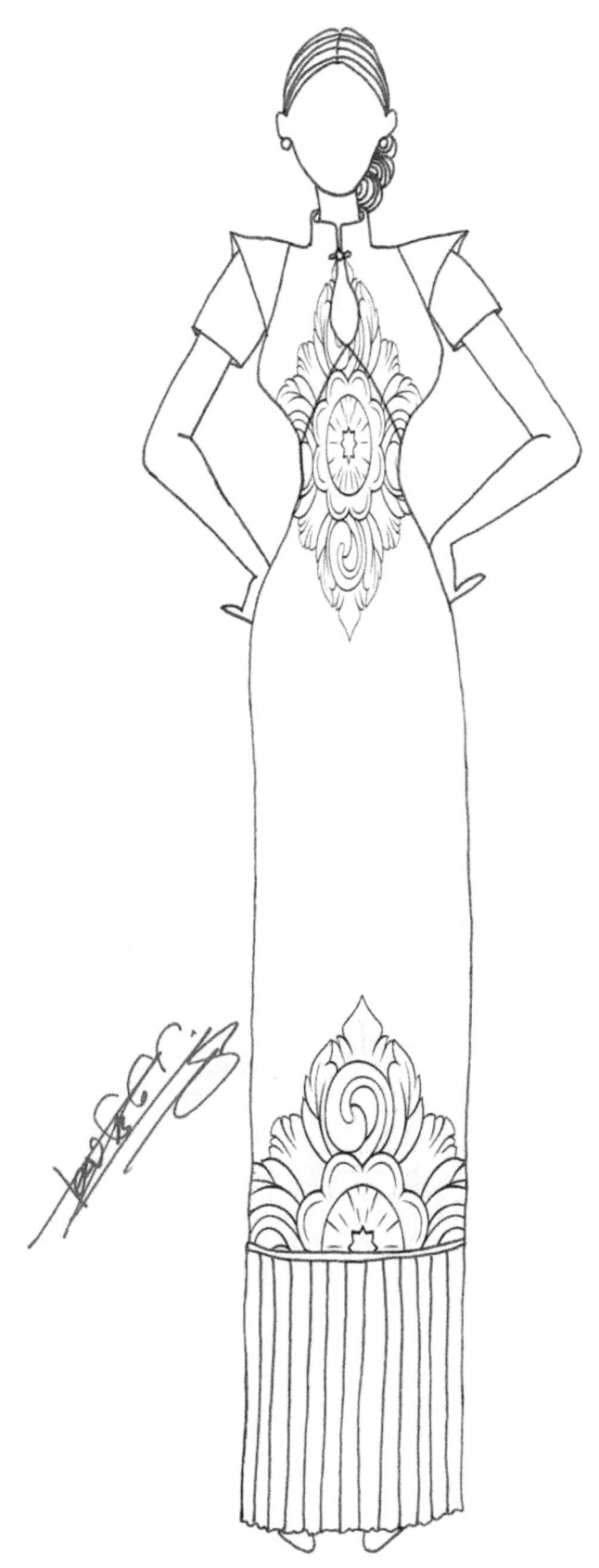

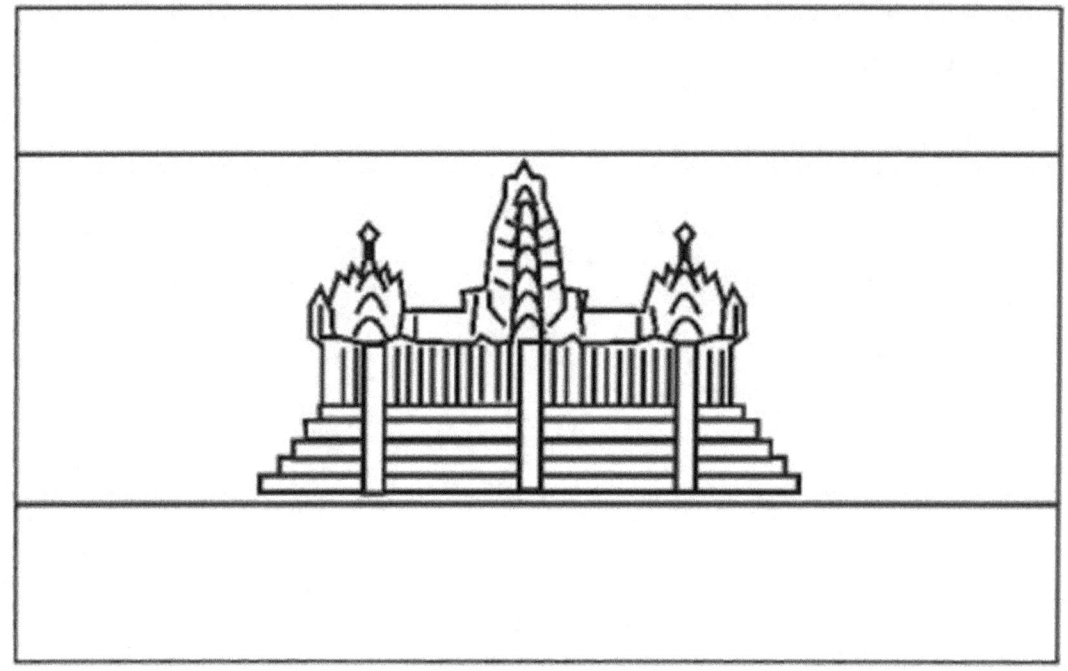

Cambodia

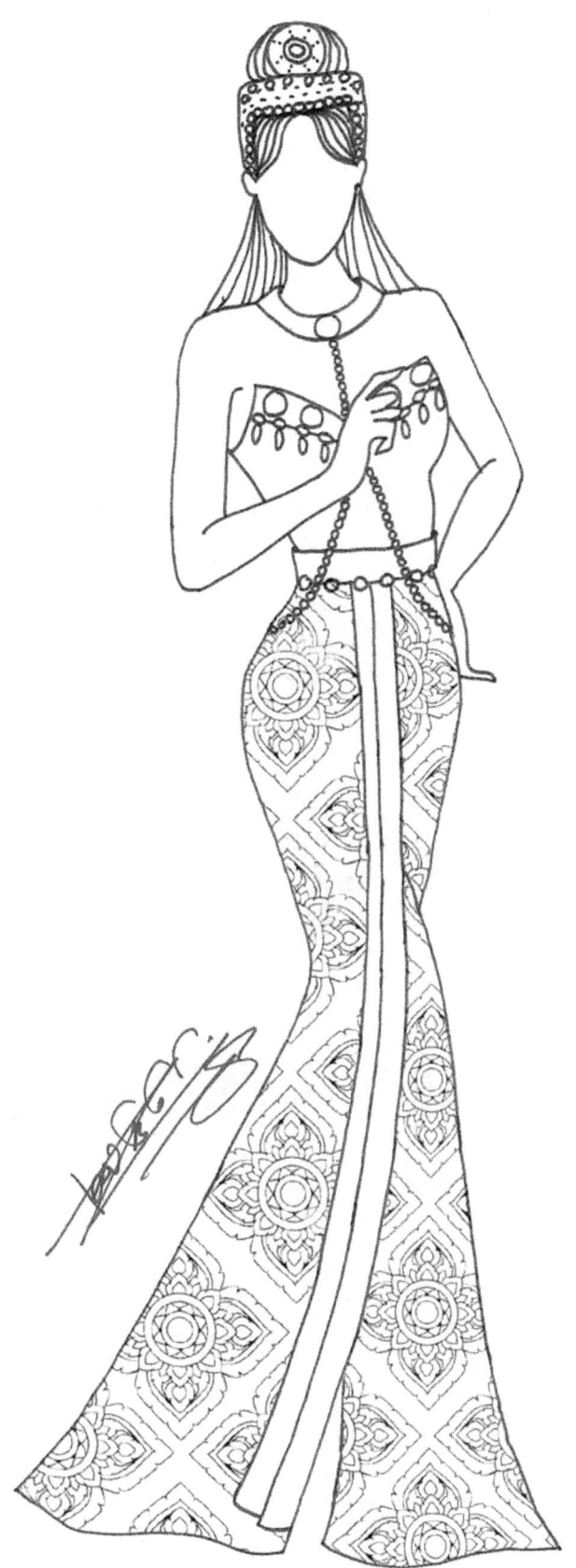

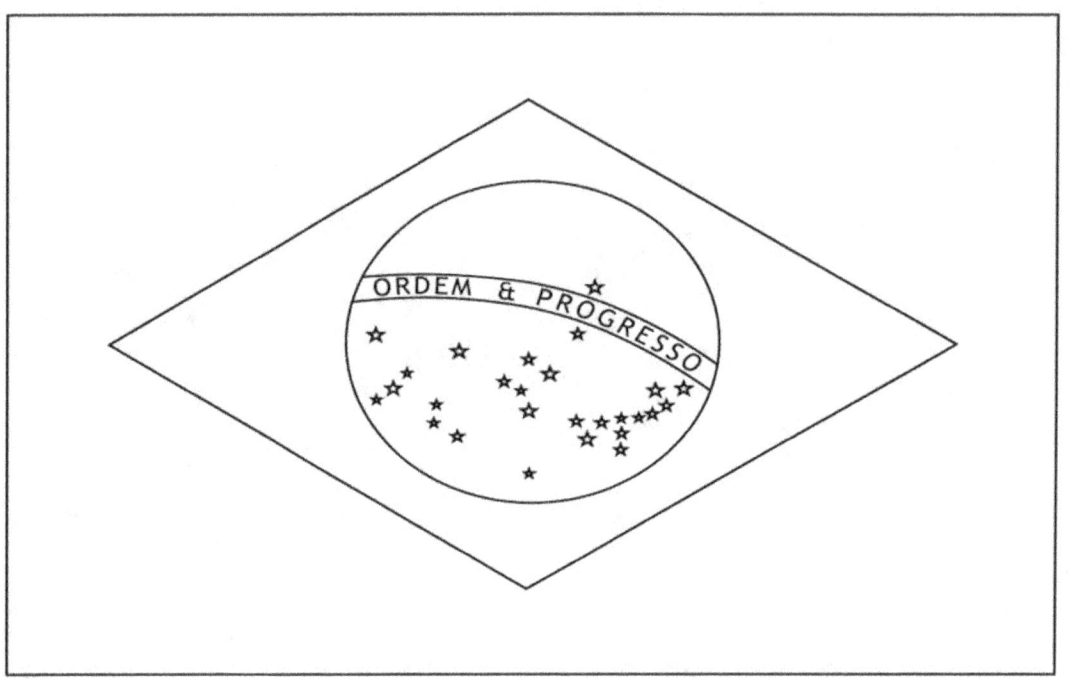

Brazil

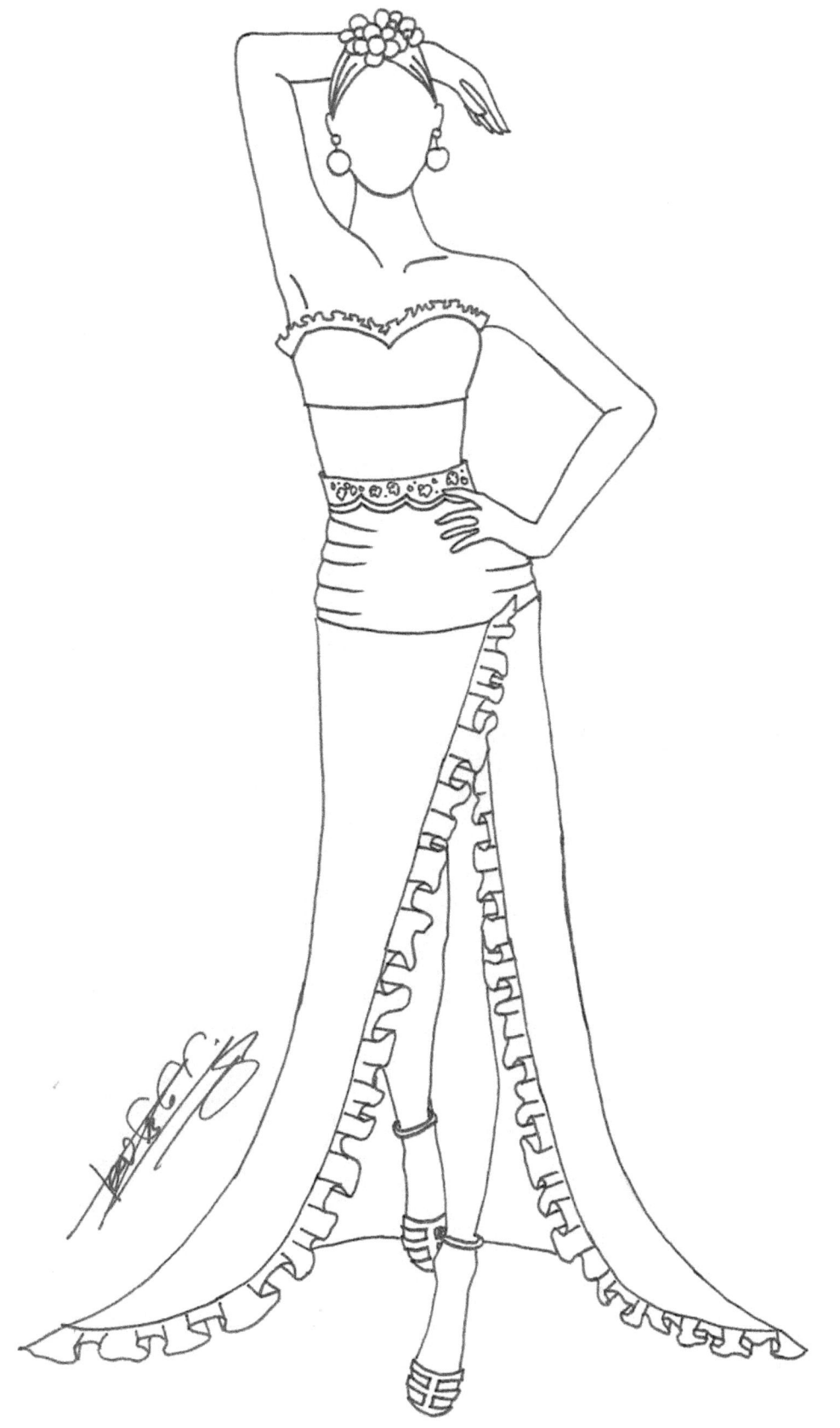

Bangladesh

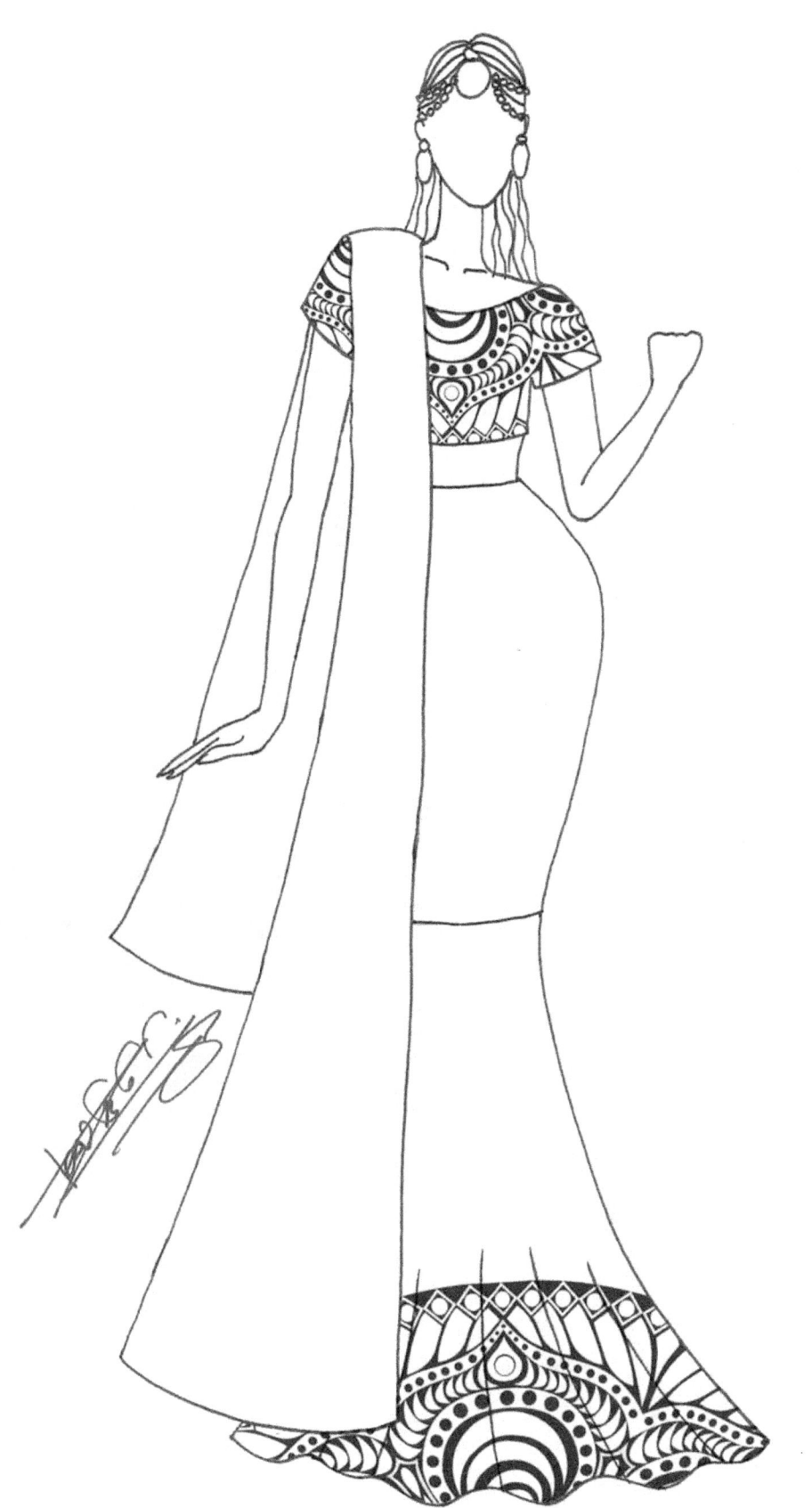

Vietnam

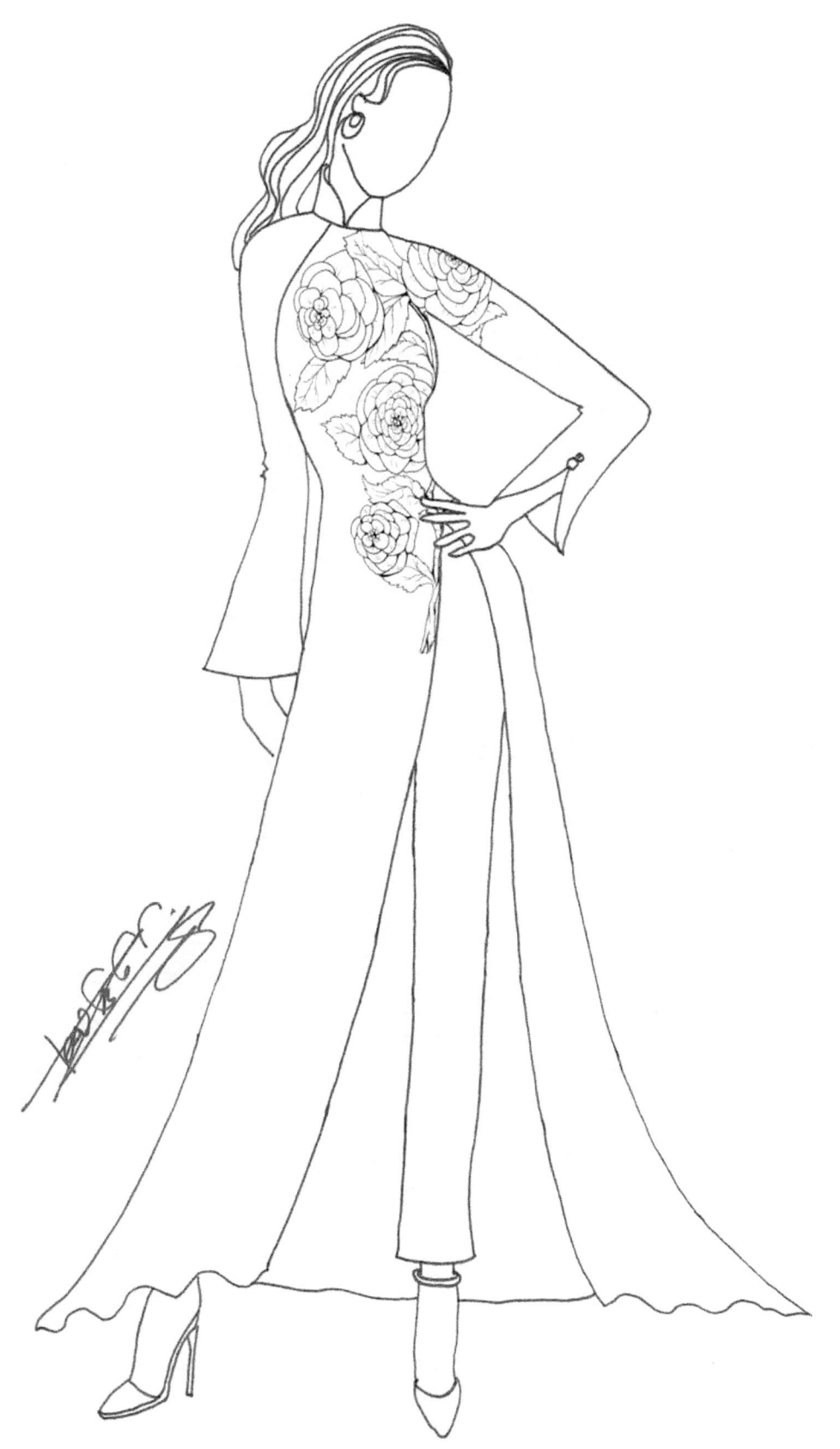

www.ingramcontent.com/pod-product-compliance
Lightning Source LLC
Chambersburg PA
CBHW081113180526
45170CB00008B/2832